Jude Law

a man for all ladies

First published in Great Britain in 2006
by Artnik
341b Queenstown Road
London SW8 4LH
UK
Artnik is an imprint of Linveco AG

© **Artnik 2006**

ISBN 1-903906-46-6

Design: Supriya Sahai

Printed and bound in Croatia by
HG-Consulting

Jude Law
a man for all ladies

MCVICAR

artnik books

Introduction

Jude Law is one of the most handsome men on the planet. He is a character actor struggling to get out of a beautiful body.

DIRECTOR ANTHONY MINGHELLA

The best actors always retain an air of mystery. The boring actors are the ones who give 100 per cent. One will never get to know the real Jude Law.

DIRECTOR PO-CHI LEONG

My only obligation is to keep myself and other people guessing.

JUDE LAW

Minghella is a colleague, friend and fan of Jude Law. In fact, if Minghella had a closet to come out of, it would be over Jude Law. He loves the man, the actor, the person... Nonetheless, to describe Jude as 'One of the most handsome men on the planet' is not hype. If you read the press clips about Jude Law, virtually every journalist who has interviewed him has broken the spine of the thesaurus trying to find an original way to describe him as handsome. His sister Natasha remembers how, when he was a 14-year-old, older girls would lay siege to their house to get their hands on what was definitely more than his angelic looks. He

just is very attractive, very good looking and very sexy.

However, long before Jude knew that he was blessed with particularly good looks, he wanted to an actor. As a 6-year-old, he became fascinated with film and from that age he was putting on amateur shows for his parents and school friends. As we know, he is now at 33 a famous actor (born 29 December, 1972) and, if not yet a great performer, already a very good one with numerous awards, including two Oscar nominations. He is now part of that unique set of actors who can 'carry' a film. Aside from that, he is also technically accomplished in that he doesn't just do variations of himself but can play a sleazy hit man in a 1930s gangster film (*Road to Perdition*) as well as a mesmeric *Dr Faustus* on stage.

This combination of looks, talent and a penchant for choosing interesting and varied roles has made him more than a pin-up for women – he also also has a considerable following of male fans, and not all of them are *camp* followers. Metrosexual man identifies with Jude: he works hard, plays harder, is attractive to women but doesn't let his kids down, and most of all is cool. When he was cutting it in the early noughties, this was Jude.

Harpers & Queen called him 'young, gorgeous and outrageously successful… There is no other actor quite like Jude Law…he can do period and modern, drama and comedy. He has looks, intelligence and passion.' And that was in 1999! Minghella, who directed him in both *The Talented Mr Ripley* and *Cold Mountain*, predicted some time ago that he would become a 'single-name actor' like Pitt, Cruise or Kidman. 'He has

all of those talents', he claimed, 'that he looks the way he does, that he's got the range he's got, that he's got the inner life that he projects on screen.'

Of course, there have been other British actors who have made it in Hollywood. Richard Burton and James Mason did, and some critics have compared Jude to them. The characters those actors played could be wild, wayward, even sexually ambiguous, but there was, as one commentator wrote, 'no doubting their essential masculinity'. Yet, with Jude, you could never really say that. Part of his charm is his sexual ambiguity. In a way, the British actor he most compares to is Dirk Bogard.

Bogard was discreetly gay all his life but he lived in times when to do otherwise would have killed his career. It is perfectly acceptable nowadays to be homosexual, so an actor like Rupert Everett will round on the press for putting cocaine usage on the same moral plane as homosexual romps. The incident that incensed Everett was closely associated with Jude, as it was about his ex-wife Sadie Frost. In the wake of the *Daily Mirror* story, in September 2005, that saw super-model Kate Moss dubbed **Cocaine Kate**, the *News of the World* revealed that two years previously she'd engaged in threesomes with Jude Law's then wife Sadie Frost and a soap actress named Davinia Taylor.

Everett said of the Moss exposés, 'Along with the revelations of drug taking, which are supposedly negative, come headlines about her lesbianism, as if that is negative too. It's shocking the way it is reported. What's wrong with her having had sex with another woman?' In an era of same sex marriage, obviously

nothing, but tabloids purport to live in a rather different moral universe than the rest of us. While that may be hypocritical, it is certainly not shocking.

Moreover, whatever point ex-rent boy Everett thought he was making is rather vitiated by the fact that the threesome was catalysed with cocaine. Kate Moss, it seems, loses her normal inhibitions – whatever they are – when she is on *charlie*, which according to her friends seems to be most of the time. The only salient point is that what is 'negative' is not so much taking drugs or indulging in lesbian romps but hanging out with the sort of skanks who feed stories to the tabloids.

Celebrity scandals sell newspapers. If stars want to present themselves to the public as clean and, in some cases, squeaky-clean – they are fair game for exposés that dish the dirt on them. After all, the fact that it is commonplace in certain circles to take Class A drugs does not affect the point that it is illegal.

By becoming a Hollywood superstar, Jude Law has also become a celebrity, a gossip column item and a target for the paparazzi. He hates this and one of his bêtes noirs is media intrusion. He typically protested to one journalist, 'I wanted to be an actor not a sex symbol. It was not my goal to become a star...'

He always set great store on protecting his private life, but that has become a lost cause. In the last few years, headlines about Jude Law the movie star have become indistinguishable from headlines about Jude Law the 'love rat', the 'wife-swapper' whose 'child swallowed ecstasy', and 'nanny-bedder'. Unfortunately for him, the greater his success in his movie career, the more

interest there has been in his private life – and the press has met that demand. Even more unfortunately for Jude Law, neither he nor his PR machine have been able to prevent the press from uncovering unsavoury episodes in his private life.

When news of this biography was first publicised, one journalist who knows him well commented, 'The problem for Jude is he has a lot to hide.' A bigger concern for Jude has been his ineptness at hiding it.

One of Jude's favourite actors is Daniel Day-Lewis. This is not merely because he admires Day-Lewis' versatility and skill as an actor but also the way he has successfully kept the prying eyes of the media out of his private life. 'No one seems to know who the real man is,' Jude has reflected, 'which is an awesome achievement in today's media-obsessed world.' He added significantly, 'He's a true actor.'

Jude believes not only in his craft, but also that this is where his responsibility to his public ends. His contract with his audience and fans is to deliver great performances, not give them access to his life off-stage. Despite all the fame, he still hasn't acclimatised to the way the spotlight doesn't discriminate between the on-stage and off-stage. In front of the paparazzi he's still like a rabbit in the headlights.

The British press tend to subscribe to the view that 'the higher you rise, the harder you should fall' – and they see their job as turning that *should* into a *will*. They have certainly done what they see as their job with Jude. They managed, for a while, to turn his life into a soap opera, but 2006 has the feel of being a turning

point. He seems to have pricked the bubbles that at one stage threatened to float him away from his chosen career path. Jude looks like he is back on track to becoming a great actor.

This is the first biography on Jude Law and, while it is written by a journalist, its intent is biographical, not exposé. It is certainly not an attempt to dish the dirt, albeit that does figure in the story: its focus, of course, is on Jude Law's life so far, but always with an eye to opening up his character and attempting to get at the man behind the mask... to clear up the 'mystery'.

Contrary to what Jude Law thinks, by virtue of him becoming a public figure (and a very wealthy one, to boot), there is a legitimate interest in showing the man. Some time in the future he will probably get around to doing that himself but it is worth recalling the comment of biographer Humphrey Carpenter who once said of autobiography that it 'is probably the most respectable form of lying'. The biography paints a different picture: less detailed, perhaps, but more measured.

I begin with an incident that still handicaps him in his attempt to find marital bliss, the prospect of which (now that that Sienna Miller has paid him back in kind) looks pretty bleak. This concerned a fling he initiated – not with one of his leading ladies or any number of the sophisticated women who would jump at the chance, but a sweet, simple girl who espoused family values and the quiet life. Her name, appropriately enough, was Daisy Wright.

JOHN McVICAR
London, April 1st 2006

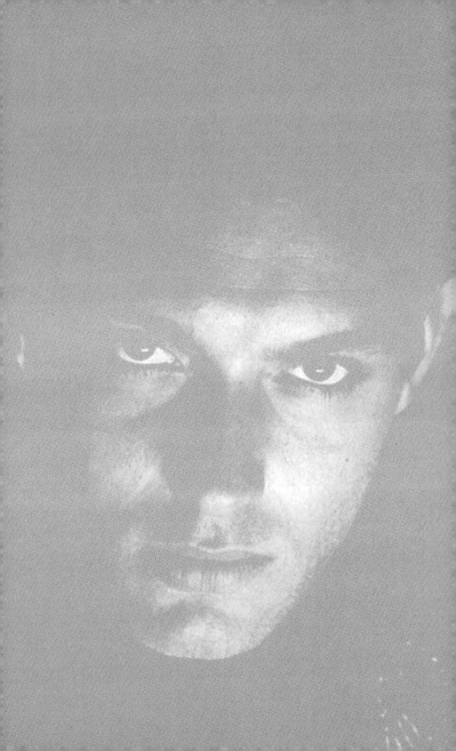

CONTENTS

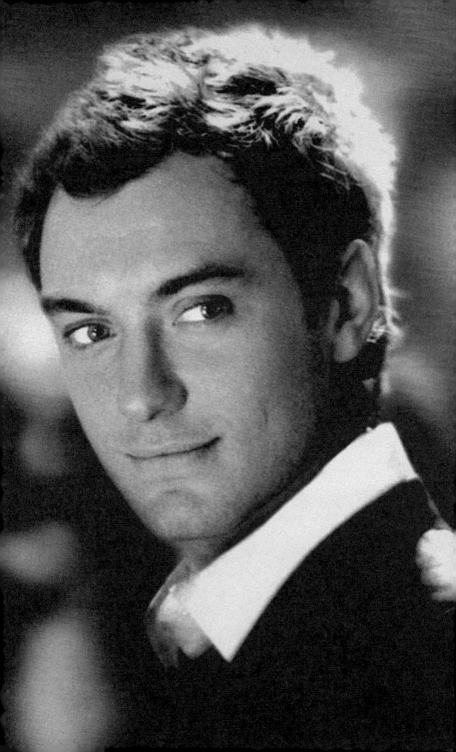

chapter one

Daisy, Daisy,
Give me your answer do!
I'm half crazy,
All for the love of you…

The institution of the great British Nanny is an ancient and venerable one. The word conjures up images of sturdy, tough battleaxes of the Victorian era: late middle-aged spinsters, clothed in 19th century severity and with a steely threat powerful enough to quieten the most boisterous child.

Alternatively it might prompt visions of women of similarly conservative dress but armed with an umbrella, a remorselessly cheery disposition and an inexplicable taste for chimney sweeps with appalling cockney accents.

In any case, even a master of the house who is known to visit women Below Stairs does not bed the nanny. Nannies are surrogate mothers and… it is utterly out of the question. Quite unthinkable.

Of course, times have changed and so have nannies. The Australian gap-year female student paying her way round the world is part of the new breed. When Sadie Frost decided to hire a nanny she had in mind Jude's straying eye and, quite explicably, she hired a rather raunchy auburn-haired young woman who had more than a touch of the Aussie look. Daisy Wright was outgoing, informal and dressed casually.

She was perfect. A name like Daisy Wright said it all: safe, boring, bovine and content to read bedtime stories to the children until the cows came home. At 26, she had been a nanny for 10 uneventful years: no illegitimate children, no dodgy dismissals, no drug con-

victions for substances that Sadie and her circle regarded as par for the course. And yet…

Okay, Daisy was no oil painting. Nor were those thunder thighs ever going to grace the kind of drainpipe jeans worn by the gamine Hollywood waifs who had ruined her marriage, but she had an earthy air and, above her child-bearing hips, braless boobs that went noticeably before her.

There was a mischievous glint in Sadie's eye: the new nanny would be looking after her and her estranged husband's three children but, as the kids shared residence of their respective homes, she would be working for Jude as much as her.

Of course, Jude was now stepping out with actress-cum-IT girl, Sienna Miller, who – due of her taste in cowboy boots – known among the Frost posse as 'Pussy-in-Boots'. Sadie knew her Jude and there must have been, as one of her friends put it, 'more than a thought in her head that this one might prove interesting.' She had once inadvertently heard Ray Winstone say about Jude, 'He's a sucker for a pair of tits.' She hired Daisy, especially for the boobs.

The trouble was – Sadie being Sadie, and always bad with the paperwork – that she did not draw up a watertight confidentiality agreement. The gagging order left loop-holes where Jude was concerned.

This was in August 2004, when Sadie and Jude had been parted for about a year. Daisy was earmarked for Iris, now four, but she still cared for the other two. By this time, both Sadie and Jude were in other committed relation-ships.

Sienna Miller, then 23, was an elfin, waif-like, expensively-highlighted blonde who, even though she was actually American, was straight off the Sloane production line. She smokes a lot, wears large black Chanel sunglasses, totes a Prada handbag and speaks with a mockney accent. Since going out with Jude, her modelling career had taken off, with the fashionistas dubbing her style 'boho chic'. She was also a sometime actress, who had studied at the Lee Strasberg Theatre and Film Institute in New York. However, until Jude secured her a role in *Alfie*, she had done little of any note. They met when she auditioned for that movie and they were now engaged. Jude proposed to her on Christmas Day, 2004. She accepted the proposal, along with the £20,000 diamond ring that went with it.

Although just nine years older than Sienna, his ten-year relationship with Sadie, their three children and his meteoric career made him a lot older in terms of experience. Jude was also a full-on father – the only thing he puts before his work is his children. There was also the fact that he is virtually a workaholic, with an explosive temper and a tendency to brood. Sienna was in love with him but at times she found the going very, very heavy. When it started to wear her out, she would take refuge in her cliquey Knightsbridge-Chelsea partying set, whom she had known since her public school days.

Partying is here a term for clubbing in fashionable nightspots where cocaine rather than alcohol is the drug of choice. Jude didn't like Sienna's crowd because it was the public school rich kids' equivalent of the rock'n'roll set that had claimed Sadie Frost. Both sets epitomise Robin Williams' line that a cocaine habit is a message from god telling you that you have too much money.

However, there is a difference. Despite what journalists write about this scene, very few of the partying ex-public school set become junkies or, worse, addicts: most of them control their habit more than it controls them. Public school installs disciplines and standards that are just not part of the curriculum in the state educational system.

During this period Jude was working on location in Louisiana filming *All the King's Men,* a remake of Robert Rossen's 1949 biopic of the corrupt U.S. politician Huey Long. Sienna had adapted to Jude's nomadic lifestyle and had been jetting in and out of New Orleans to see him. Then, at the end of January, the *News of the World* splashed on a wife-swapping story involving Jude and Sadie that had occurred some time before she had even met him. Sienna was shocked and 'freaked out' when she confronted Jude. Wife-swapping was just too sordid and lower-class for words. One friend pointed out the obvious: 'She is quite straight, has got lots of posh friends and is very much a public school girl. She's not got that attitude which Sadie had to go with it.' At first he also lied and, as always with Jude, lost his temper as she pressed him on something that, since it dated from before he'd met her, he viewed as none of her business.

Jude rode out the public embarrassment by continuing to work and threatening legal action against anyone who repeated the allegations, but inevitably his relationship with Sienna cooled. As the new cover girl she was on the guest list of every party to launch new products and she inevitably bumped into a few exes. She was continually being snapped partying at this or that nightspot, which infuriated Jude. What with her fashion work, modelling and partying it was all very déjà vu of Sadie. He began

sulking, as is his wont. She did come out to New Orleans in March, but there was no physical warmth between them.

When Sienna flew out, nanny Daisy Wright came in with 4-year-old Rudy to join Rafferty, 8, who was already there. Jude had been given an invitation to see Robert Plant in concert at the Beau Rivage casino resort in Biloxi, Mississippi, and he took Daisy and his oldest boy Rafferty along. Daisy's diary entry reads:

> *We went out and had a great time at the concert. We had a few beers and we got a little bit drunk. Then after the show had finished we got invited to go back stage to meet Robert and the band.*

> *We went to their dressing rooms, had wine and pizza with them and chatted. By then I was feeling rather jolly. Jude was having his picture taken with various people. I stayed on chatting to members of the band and Robert took my phone number because he was doing a show in London and said he would love to invite me. Then, as we were about to start the two-hour drive back to New Orleans I asked Jude if I could have a bottle of wine for the journey.*

In the limo going back, Rafferty was asleep and the two chatted while eating some pizza and drinking wine. He complained to her about how difficult it was to live in the public eye. 'I may be Jude Law but at the end of the day I am an ordinary guy who wants ordinary things.'

Like any ordinary man of the house he was looking to shag the nanny and, when they got back, Daisy put Rafferty to bed, then rejoined Jude who began talking

freely and openly about Sadie and Sienna. He complained to her that they were both professional women who put their own career before looking after him and, unlike him, they liked going out on the town.

Daisy replied that she didn't understand why he couldn't find a wife who wanted to stay at home with him and look after him and the children, not one who wanted to party and be a career girl. Jude told her he wanted that more than anything, but such women didn't exist in his world. Daisy, who had left school ten years earlier at the age of 16 and had been a nanny ever since, told him that was what she wanted with all her heart. According to the diary: 'He said how wonderful he thought I was.' He then said, 'You're very special to want that and it's an amazing way to be.'

Of course we don't have Jude's version of the dialogue but, given that he didn't question anything when the story broke, Daisy's account is unchallenged and therefore, if only by default, accurate. To say it might have been embroidered by the *Sunday Mirror* journalists rather begs the question why they didn't make it more dramatic, sexy or merely more interesting than it actually is. In fact, what is interesting is it really does read like it is the unvarnished truth.

When she went to leave to go her bedroom, Jude gave her a 'beautiful kiss on the lips' and told her, 'If you are lonely come and see me.' Daisy told him not to be silly to which he replied, 'No seriously, it's a big house and you might get lonely.' This is hardly seduction dialogue that would earn the scriptwriter guild's stamp of excellence, but what Jude lacks in chat-lines, he makes up for in bed.

The next moment they were all over each other, ripping each other's clothes off before they had what Daisy calls, 'mind-blowing rampant sex... He was holding me tight and we were kissing, it was amazing, wonderful. Jude smelt so manly. He told me I was wonderful. I could feel my whole body tingling, it felt so lovely.' It's uncertain whether or not Daisy is using 'tingle' as a euphemism for the Big O, but she continues, 'We explored each other's bodies intimately and gave each other pleasure.'

How touching! According to Daisy, Jude certainly 'knows how to satisfy a woman'. However, having blown each other's minds, Jude seemed to feel the prescribed guilt. Daisy returned to her own room, disappointed that she had been used. She couldn't sleep, and when she went back for a hug they 'had more lovely sex' then fell asleep in each other's arms. This, incidentally, was the same bed that Sienna had slept in the previous night. Daisy could still smell her perfume on the pillow.

The *Sunday Mirror* (which, as a family newspaper has a duty to its readership to establish such facts) reported that the pair had 'wild sex three times on the first night together'. No kiss 'n' tell story is complete without this kind of count. Of course, it very MCP-ish that the focus is on the number of male orgasms. However, that is the convention, so we are left high and dry on how often Daisy tingled.

They were awoken by Rudy, who had wandered into the bedroom. He said to Jude, 'Daddy, I'm having a bad dream.' Daisy recalled that Jude told him, 'It's all right darling. Go back to bed.' When Rafferty left they took this as a wake-up call to do some more tingling and mind-blowing. But according to Daisy this last tingling session was in the morning, so strictly Jude is only a twice-a-night and once-in-the-morning man. After all, if we have to have numbers, then reporters have some kind of responsibility to make them add up.

That day the whole entourage, including another nanny, left for New Iberia, where they were filming *All The King's Men*. That evening, when Daisy was putting Rafferty to bed, the child asked, 'Daisy, why were you in Daddy's bed?' Understandably gobsmacked, Daisy's reaction was to say nothing and just think, 'Oh fuck.' Uppermost in Daisy's mind was *what if Rudy told Sadie?* A couple of days later, she casually asked him if he'd seen her in bed with Daddy and he answered, 'I think you were.'

When Jude returned home from filming, Daisy told him what had happened. 'Jude told me not to worry and we went to our bedrooms,' recalled Daisy.

> *Later I walked into his room in my pyjamas and we ended up making love. He said, 'I feel so close to you. You have become such a good friend.' We fell asleep together. I really wanted to ask what was going to happen between us but didn't dare. We both said how sad it was we were going back to England.*

The entourage returned to New Orleans, with Daisy and another nanny looking after the children while Jude was busy filming. On April 9, they all went to the French

Quarter Festival.

Daisy wrote in her diary: 'Jude was being hassled everywhere by fans. We listened to great music, Jude and I drank beer and went home to get ready for the film wrap party.' The children, Daisy and a second nanny all went to the party. But Daisy was able to stay later because the other nanny took the younger ones home.

Both Daisy and Jude drank a lot of wine, and she danced with the crew. At the 'after party' they drank more before stumbling into Jude's chauffeur-driven car to return home around 2 am. Daisy's diary takes up the tale:

> *Everyone was asleep upstairs and we just kissed and kissed at the front of the house. It was so beautiful. He makes me feel so lovely. I think I am falling in love with him. We went inside with our beers. We were chatting about us and the holiday and how sad it was all coming to an end. He pulled me on to his lap and kissed my neck. We looked at each other and he said, 'I think you are so beautiful and special. You are far too good for me.'*

> *I didn't really know what to say, so I just said, 'I probably am!'*

This, according to the diary, was all said quite solemnly, without either or both of them collapsing in a fit of laughter. Jude is an outstanding actor, but these lines came from the heart – not some script that he improvised on the spot.

This was the night when they made love on the pool table, which the owner later auctioned on eBay. Daisy told the *Sunday Mirror*: 'That was one of the best nights

of my life. I will never forget the balls flying everywhere around us. We were really drunk and went to our separate beds and passed out.' The peculiar thing is that he made love to Nia Long (Lonette) in the vacuous *Alfie* on a pool table. Given that he met Sienna while making this film, he must have been aware of the symbolism of what he was doing. Psychologically he was paying Sienna back for not only blaming him over the wife-swapping debacle but also failing to support him when he was being humiliated in the media as being exactly what he always avowed he wasn't – a bit of an Alfie.

But Jude was rampant again, which Daisy faithfully recorded in her diary:

> *The next thing I knew Jude was climbing in bed next to me, kissing me and saying he didn't want me to go. Then I heard one of the kids cough and told him to go back to bed.*

The following day Daisy was due to fly back to England with the children. Jude said his farewells on set in his trailer. 'He gave me a big kiss on the lips, which shocked me, and we hugged,' remembered Daisy. She doesn't say why she was shocked because it wasn't in front of the children. After all, for a month they had already '…explored each other's bodies intimately and gave each other pleasure'. Daisy continued:

> *I was a bit sad on the plane because I had fallen for him. I suppose I hoped he would ask me to marry him. A stupid dream I know. Why would someone like Jude Law want Li'l' Ol' Me?*

The acrimonious break-up of their marriage had taken its toll on Jude and Sadie. Even in public and in front of the children, they'd been unable to stop themselves from screaming and shouting at each other. With Sienna, Jude had found a safe harbour from the storm. Gradually, though, the undercurrents with her revelling in the celebrity spotlight had disturbed his equilibrium. Then, like the recurrence of a dormant disease, his open-marriage antics with Sadie had been splashed all over the *News of the World*. He'd put his head down and just tried to work his way through the humiliation and embarrassment but Sienna had become cold, distant and reproachful. The maternal, submissive, adoring, uncom-plicated Daisy had been a therapeutic outlet for his bruised and battered emotions.

A friend of Jude's put it well, 'Look, Jude had had it up to here. Sadie had been twisting the knife for ages, then, after *The Screws* did him over the wife-swapping, Sienna got on his back, sticking in the stiletto. And don't forget all the time he's working like a dog… except no dog I've ever had did a stroke. But you know what I mean. The nanny was a mercy-fuck. Grateful for what she received and horny as hell too. It did him good. The trouble is Sadie found out.'

Daisy returned the children to Sadie who had come back from Spain with her toy boy, Jackson Scott. The nanny then took some time off. Meanwhile, Sadie had some friends round for supper with the kids. In front of everyone, Rudy said, 'Mummy, why was Daddy in bed with Daisy?' Sadie gently asked how she knew this. 'They were in bed. I saw them.' Sadie nearly blew a gasket there and then. She rang Jude in New Orleans.

There was no small talk. 'Jude, tell the truth for once. You've been fucking Daisy haven't you? The nanny! You've been fucking the nanny and, if that isn't enough, for christsake, you been doing it in front of the children,' she shouted over his denials.

Jude had guessed it was coming. As the details emerged – which he pretended he didn't know – he denied, denied, denied: 'Sadie, this is mad. Sienna was here. She left as Daisy arrived. Am I that desperate? Rudy came in the bedroom but I was on my own. He imagined it, honestly. He'd had a nightmare or something and he must have imagined it. I asked Daisy to make a fuss of him before I went to work…'

Sadie knew that Jude had a roving eye, but Jude is a good actor. She wobbled…maybe Raff had become muddled. Nonetheless, she resolved there and then to sack Daisy.

She returned to the dining room. 'He denies it,' she announced stony-faced to her guests. They said nothing but didn't have to as their look, 'what d'you expect him to say', said it all. Sadie fished out her mobile and rang Daisy. The phone was engaged. She immediately re-rang Jude. His phone was engaged too. She rang Raina Curle, her PA, and explained her predicament.

Daisy was taking a break on the Riviera and did not pick up Raina's calls. When she returned, she rang Raina. The PA asked her if she had been sleeping with Jude. As he had told her to, she also denied, denied, denied. Daisy then rang Sadie and told her of Raina's question, but when Sadie iterated the accusation she replied, 'Gosh no, I should be so lucky.' Her nanny days in the Frost household were numbered.

Daisy is bovine but, as any dairy farmer will tell you, even cows know when the grass is greener on the other side of the fence. She saved Jude's text and voice messages. A friend told her that she must begin taping his calls and keeping his text messages, and also write up a diary of what had occurred during her period in New Orleans. She observed the advice.

She rang Jude about how worried she was over losing her job and he promised he'd find her another one. As a way of placating her, he floated nannying for the Beckhams, but it was all made up. Nonetheless, in the few days before her kiss'n'tell story broke in the *Sunday Mirror*, Jude was smooching her with stories about how upset he was at the idea that he would never see her again. She never told him what she was doing, or that the *Mirror* journalists were a party to these phone calls.

She was sacked and when the story broke, Sadie told the press, 'This is between Jude and Sienna but what I will say is that a situation like this was predictable.' Sadie hired a new nanny…a frumpy, middle-aged battleaxe.

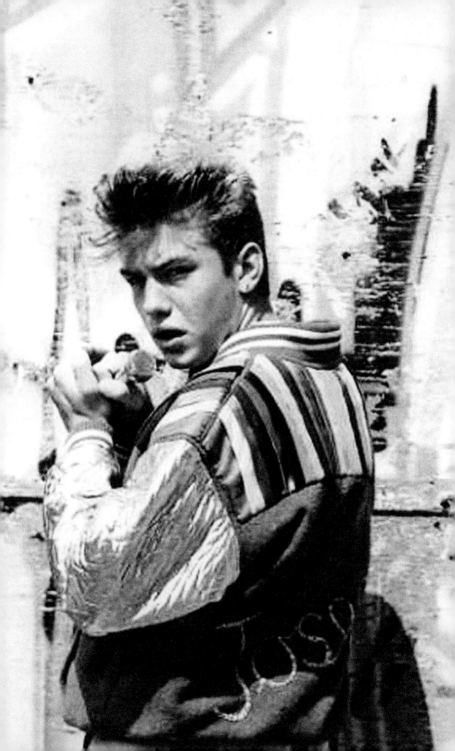

chapter two

And any time you feel the pain
Hey Jude refrain, don't carry the
world upon your shoulders
For well you know that it's a fool
Who plays it cool by making his
world a little colder

THE BEATLES, 'HEY JUDE'

Born to Peter and Maggie Law on 29 December 1972 at Lewisham General Hospital, David Jude Heyworth Law's upbringing was an uneventful one.

His parents had met while they were training as teachers at Goldsmiths College, and Jude and his older sister by 18 months, Natasha, were raised in a traditional lower-middle class home with few pretensions. His parents were left-wing children of the 60s – very laid-back and right-on, but far from hippies. 'No hash cakes for breakfast and kaftans,' Jude noted. 'More upwardly mobile bohemian.'

Jude the Obscure, Thomas Hardy's novel of social repression, may seem like an odd choice for an 'upwardly mobile bohemian' mother to name her child after. But Maggie Law was reading it during her pregnancy and liked the name so much she decided to christen her son Jude, choosing to ignore the less pleasant aspects of the book, which is a miserable catalogue of debauchery and death. 'Hey Jude', the Beatles' massive trans-Atlantic number one single, was still on the radio, too, and the two together sealed the choice. Her youngest child was to be Jude. Jude didn't actually read the novel himself until he was 18. 'So depressing' was his only comment.

Jude was later to wish she had been reading something else while she was pregnant. As both his parents taught in state schools and had decidedly liberal views, they sent Jude to his local comprehensive, Kidbrooke.

He started off promisingly, discovering a love for drama at the tender age of five when he played St. George in *St. George and the Dragon*. 'The joy I felt at being on stage in front of people – that's when I first wanted to be an actor,' he claimed. He later said that he naturally understood 'the

concept of creating imaginative scenarios' and his love of acting continued throughout his youth.

The Arts were a central feature of family life in the Law house: Maggie was a keen amateur dramatist and the family used to make frequent trips to the theatre and cinema. Jude loved these outings, and from an early age he was clearly destined for the boards. Peter would accompany the kids to the cinema. The first film Jude saw in the cinema was Disney's *The Rescuers.* He was four and Natasha five and half – yet it was she who became scared at watching the film on the big screen in the dark, and their father had to comfort and reassure her. Jude, on the other hand, was just awestruck at the power of what he already understood was a make-believe product… a fantasy that was real.

The children were also encouraged to stage plays at home. Natasha remembers the productions she and Jude used to put on for their parents: 'We had this big dressing-up box and were always putting on full-scale productions. They had to be properly rehearsed and directed because Jude was such a perfectionist. They also had to feature cowboys. God, we did a lot of cowboy dramas.'

Encouraging their son's love for the stage, Maggie and Peter joined Jude up to the junior wing of the Eltham Little Theatre, and Jude is well aware of the debt his acting career owes to such understanding parents: 'From about the age of six I knew that was what I wanted to do. My parents were never pushy but they were encouraging.'

But despite being allowed to play cowboys and Indians, his parents were progressive liberals and Jude was raised

by full-on feminist values: there were no *Female Eunuchs* in the Law household. Respect for women, thespian leanings and a name like Jude didn't go down to well with the playground Al Capones at Kidbrooke. The disintegration of the educational system and a changing catchment area meant that the school's character changed fundamentally.

Boys like Neil and Jamie Arcourt and Luke Knight, who were involved in murdering Stephen Lawrence, became his classmates. Later, as the case against them disintegrated, Jude commented angrily, 'I remember scum like that.' The white underclass pupils targeted anyone who was different, and Jude was very different. He was bullied for his artistic interests, and spent a large amount of his time avoiding the gangs that victimised children like him; middle-class, respectful to authority, interested in schoolwork…

'I was labelled a poof from day one,' he recalled. 'I was even hung out of a window by my ankles, five floors up, by a boy called Spencer Gaffer. It was a nasty, tough place, but politically my parents wanted me to have a comprehensive education because they both worked in state schools.' In the end the worm turned, and he began to fight back. He met violence with violence and he remembers it as one of the few lessons he learned at Kidbrooke.

As a break from school, Jude joined the National Youth Music Theatre when he was 12. Still running today, the organisation gives young people throughout the country the chance to take part in musicals and light opera, and develop their acting and singing talents. Jude credits it with his early acting training, and met many of his best

friends while there, including Johnny Lee Miller.

On one residential course with the NYMT soon after he joined, Jude was placed in the wrong dormitory after staff mistook the name 'Jude' for a girl's. 'I was put in with a group of 11 and 12 year old girls,' he remembered. 'I didn't tell anyone but it didn't last for long. I got found out and moved.' According to the founder of the NYMT, Jeremy Taylor, Jude didn't kick up too much of a fuss: 'We found him up there in the dorm just before bedtime having a great time. I felt a bit of a killjoy putting him in with the guys.'

The NYMT's productions are diverse in the extreme. Jude was cast as Joseph in *Joseph and the Amazing Technicolor Dreamcoat* and, according to Taylor, the girls 'went bananas' – something he quickly became used to. Jude, however, would have preferred a part in that season's other production, Brecht's *The Caucasian Chalk Circle* 'because I was a pretentious little prick and wanted to be in a Brecht play,' he confessed much later. His penchant for picking roles based on his own interest rather than what would be most popular is clearly one that developed early on in his career, but which remains with him still.

By the age of 14, after only one television appearance (a brief review of *101 Dalmatians*) Jude had started to write his first book, entitled, somewhat optimistically, *My Autobiography*. One of Jude's greatest inspirations as he was growing up was Daniel Day Lewis, a brilliantly versatile but intensely private actor. The fact that so little was known about the man behind the roles impressed Jude so much that he too vowed to keep his private and public lives separate if he ever reached a similar level of

fame. Jude cites any number of actors as his inspiration – Robert Mitchum, Marlon Brando, Paul Newman – but Day-Lewis is the one whose influence can be seen most clearly in Jude's attempts to keep himself out of the public eye.

By this time, Kidbrooke had become unbearable, and when Jude's friend was seriously beaten up in a fight, Jude's parents swallowed their political principles and let him transfer to Alleyn's, a private school, in nearby Dulwich. It turned out that Alleyn's, with its emphasis on the liberal arts, was much better suited to Jude than Kidbrooke had been, but there he ran into a different kind of prejudice.

Whereas at Kidbrooke he'd been labelled as 'posh' and bullied accordingly, at Alleyn's he found himself classified

as the 'oik'. In a completely different environment, what he brought from Kidbrooke marked him out as lower-class. He was surrounded by kids whose parents didn't blink at the school fees and were used to a much more privileged lifestyle. Jude's response to his first humbling before the English class system was to the became the hard-case with an accent and an attitude to match. At one stage, he even had his hair cropped like a skinhead.

Although he loved the emphasis on theatre, he socialised mainly with the girls at Alleyn's to avoid the ribbing that came from the boys. This made him pretty unpopular, as it looked as though Jude was stealing all the girls. Natasha remembers how popular he was with them: 'At the age of 14, he was seeing girls in the sixth form. They were all absolutely mad for him.'

Still, every teenage boy needs something to embarrass him in front of the fairer sex, and for Jude it was his house colours. Every student at Alleyn's was put into a house according to sporting ability or parental legacy. As Jude had transferred late, none of these applied, so he was put in Spurgeon's house. Unfortunately, the Spurgeon's house colour was pink, and Jude was forced to wear a pink tie for school and a black and pink top for sports. For a 15-year-old in London in the 80s, wearing a pink games shirt was tantamount to sartorial suicide, and he had to put up with the usual innuendos that pink shirt attract from schoolmates in other houses. Still, Jude was a keen footballer and would sulk if Spurgeon's lost a game.

Even though he was keen on sport, however, he was definitely not one of the lads. Most of his friends were girls, largely from successful families, and together they became known as 'the Blackheath lot'. Despite being a

firm fixture in this clique – he and his girlfriend were the leading lights of the pack – Jude still felt something of an outsider because of his background. 'The cool kids and the jocks, the dumb kids and the smart – I never felt like I was one of them and I hated the fucking politics of that.'

What he hated most of all was the effortless superiority of his social betters, even though he rejected the basis on which it was claimed. Nonetheless, the insidious omniscient forces of the English class system had conditioned another inferiority complex. To this day, Jude's sensibilities react with a mixture of resentment and deference when he encounters his social betters.

He resolved to make his own way out of class typecasting, which was by acting, but this meant neglecting his education. He rejected the school system: 'They were all sheep, fearful and terrified of shaking the cage at all... I realised that I became a much happier, much nicer person when I did leave.'

Jude's academic performance was poor. He took GCSEs in Art, Geography, French, History, Biology, Drama, Maths and English. Even in the less academic subjects, he didn't exactly shine. Leila Supiramaniam, who sat next to him in the remedial French class, recalled: 'He was pretty bad at Maths and Science and completely colour-blind – he once painted the grass on his school GCSE art exam blue.'

However unimpressive his academic results, his talent on stage did not go unnoticed. Jude was often given leading roles in school plays, but drama was only part of the A-level curriculum and he wasn't allowed to study it formally until he reached the sixth form. Nevertheless,

when he was still only in middle school, Jude was given the lead part in a production of *Captain Stirrick*, the story of child thief Ned Stirrick and his gang of pickpockets. The director was teacher Eileen Chivers who immediately recognised Jude's talent; she did what she could to foster it and her belief and encouragement were an inspiration to Jude. She soon became his favourite teacher, and he couldn't wait to escape the monotony of his other lessons for the fun to be had in his drama classes. 'It was the only class where you felt like the teacher's opinion was on exactly the same level as everyone else's,' Jude later remarked, 'and whoever had the best idea, that's what stood.'

Buster Keaton in *Sidewalks of New York*, 1931

As soon as he was able to, Jude signed up to Chivers' A-level drama course, and it wasn't long before he got his first real break. Thames Television was making a short adaptation of Beatrix Potter's *The Tailor of Gloucester*, and Jude auditioned for and was cast as Sam, the Mayor's stable boy. With a cast that included Thora Hird, Barrie Ingham and Ian Holm, Jude was in exalted company, and he acquitted himself surprisingly well for someone so young.

Looking like a typically awkward, gangly teen who

hadn't yet grown into his skin, he delivered his lines with confidence: 'I ain't afraid of no mice,' he tells Mrs. Speck, managing the old-fashioned English and perfect Gloucestershire accent with aplomb. Despite the short-comings of the film as a whole, Jude's ability and confidence in front of the camera were already apparent. As Eileen Chivers had recognised, he was a star in the making.

Mike Tonkin, Jude's sixth form tutor and now head of drama at Alleyn's, recalled a school production of Chekov's play *The Seagull* in December 1989, in which Jude played the tragic lead, Sorin. Jude didn't reserve his talent for the appearances which would help his career – he gave his all whatever the production and however minor it might have seemed. 'It was a fantastic performance,' Tonkin remembered. 'He was a very talented, sensitive boy actor of 17. And two things struck me – his almost intuitive ability in drama, and the fact that he was a genuinely intelligent, nice kid. He was in a fantastic group who all had a real commitment to the theatre. At 17 it was difficult to mark Jude out as a star of the future but he was excellent on the stage. We did a lot of practical work in class and he would improvise to a very sophisticated level. But he wasn't as driven as some of these intense kids you see. He certainly didn't have all that attendant baggage of bullshit – the "I'm-gonna-be-a-star" attitude.'

In the same year as his performance as Sorin, Jude went on a school trip to south London's Young Vic theatre to see Ian McKellen and Imogen Stubbs in Shakespeare's *Othello*. 'Being a precocious school kid, I was really struck by the intimacy of the place,' Jude said, displaying an affection for the theatre which would last into adulthood. 'It's one thing to go to the National and see

McKellen perform, and quite another to have him almost in your lap.'

It wasn't long before he witnessed McKellen in action again, this time giving a reading before the bulldozers moved in on London's historical Elizabethan theatre, The Rose, to cover up the landmark, if not forever, for the foreseeable future.

Eileen Chivers was a driving force in the campaign to save the Rose, which boasted the founder of Alleyn's – Edward Alleyn, one of the great Elizabethan actors – among the many performers to tread the boards of the theatre. The Saturday morning before the site finally succumbed to the developers, Chivers took a group of her A-level students to the theatre for one last attempt at saving it.20

She was like the pied piper, leading her troops along the streets of London. And that morning, Jude would get to share the limelight with McKellen. The young Jude stood on the old wooden stage and began reading from Marlowe's *Dr. Faustus*, a play which he would revisit many times on several London stages. There is a photo of Jude, dressed in Elizabethan clothes, delivering his lines as if it were the last and most important performance of his life.

Unfortunately, the contractors were less than impressed with the combined performances of Jude, McKellen and many other high-profile actors, and The Rose is now entombed in concrete.

Towards the end of his lower 6th year, Jude was facing the choice of staying on at Alleyn's to pursue a University degree course in drama or leaving to try to make it as an actor then and there. Despite the pressure of his parents

to stay on, as far as Jude was concerned school had been a stop-gap to acting. He had disliked the structured aspect of school and had no appetite for the slog to get into university. Most of all it was the class system, however: 'I didn't like the institutional side,' he later commented, 'or how quickly people were willing to be sheep. I just wouldn't kowtow to these football captain idols of whatever... The careers people said "You're gonna be an architect" or whatever, and I said, "No I'm not, I'm gonna be an actor".'

Having made the decision to leave, he was gratified to find that this leap into the unknown had paid off. In 1990 he was given a part in the NYMT production of Brecht's *The Caucasian Chalk Circle* – a play he had been wanting to do for some time – and somebody must have been watching: as a result of his performance he was offered a part in a new soap opera, *Families*, for Granada TV. Jude had dropped out of school just a year shy of his A-levels.

Although he knew it was important to cut his intellectual teeth, expecting him to turn down such an offer was like asking Wayne Rooney to pass on a chance to play for Man U in order to learn to read and write. 'When I left school and got a job, that's when I suddenly felt happy, properly, for the first time,' he said. 'Acting was a language I understood instinctively.'

However, although Jude was delighted to have found a job so soon after deciding to leave school, *Families* – billed as the UK's answer to *Neighbours* – failed to live up to expectations. The main compensation was that he lived in a flat in Manchester and hung out with his young co-star and friend from the NYMT, Jonny Lee Miller. The pair had a blast; the money was good and they partied as

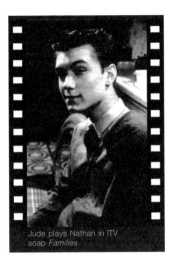

Jude plays Nathan in ITV soap *Families*

hard as they worked. 'I went bananas,' Jude remembers. He acquired a rep-utation as a womaniser and heart-breaker, but not with the flinty, callous edge that Michael Caine portrayed in *Alfie*. Jude charmed women in and out of his bed and his upbringing ensured that he agonised about it later.

But all was not all rosy on the set. He found he was having to spend more and more time working with the scriptwriter on the atrocious dialogue he was supposed to deliver and, after sticking it out for 14 months, he decided to call it quits. The show only lasted another four months before bad reviews and worse ratings finally killed it. Nonetheless, Jude had had a fast track initiation into the ins and outs of TV acting. Years later, appearing on America's *Rosie O'Donnell Show*, Jude remembered his time on *Families*: 'It was the bucket end of soaps... I'm not even going to go on about it, it was terrible. But it was a fast way to learn how to deal with camera angles and learn lines quickly. In England there used to be 'rep' theatre season when young actors and actresses could do four plays in a summer season. This felt like a similar kind of thing.'

All the time that he was filming *Families*, Jude was auditioning for other roles. The first was for a part in a low-budget feature film with Ewan McGregor. The director, wanting to see the pair in action, gave them £20 to devise an improvised scene. Setting the tone for their

subsequent friendship, however, Jude and Ewan promptly disappeared down the local pub and drank the proceeds. Neither scene nor film were ever made, but a friendship was forged over those many pints, which still endures today.

There was a small trickle of TV parts coming Jude's way – his good looks, cleft chin, chiselled jaw and green eyes ensured that he would always have some work, however low-brow it may have been. But he swiftly decided that the way forward lay in London.

Returning to London, he moved into a flat with Ewan McGregor and Jonny Lee Miller. 'They were great times,' he remembered. 'Just as anyone has fond memories of being 18 or 19. But I was never a fan of going out, picking up, doing all that. I was a bigger fan of partners rather than serial dating.' Of course, the other two remember it slightly differently, but hindsight tends to the rose-tinted.

Jude's main problem with ratting around, however, was not the lying and cheating, it was the way it distracted him from his real commitment – his acting career. His parents had run a committed marriage from the time they met at university. They didn't like this side of Jude and his mother, in particular, was a forceful advocate of commitment and the bounty it delivers, a base from which one can better achieve something worthwhile.

The TV work paid the bills, but it was largely unexciting and Jude recognised he needed more training. 'I'd earned a lot of money. I'd spent a lot of money. But I hadn't paid my dues,' he admitted.

Much to his parents' delight, he finally decided to

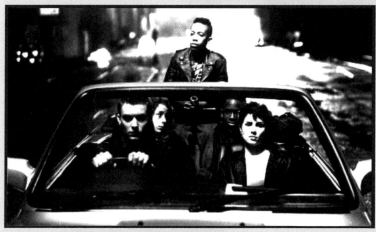

Jude Law, Sadie Frost and other cast members in Paul Anderso's *Shopping*, 1993

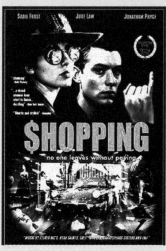

audition for drama school. Surprisingly, he was rejected, but it proved a blessing in disguise as his stage career suddenly took off.

After a role in *Pygmalion* which toured around Italy, he auditioned for a role in a production of *The Fastest Clock in the Universe* at the Hampstead Theatre. The play attracted good reviews and gradually Jude found he was getting work that demanded much more of him as an actor.

His first venture into film was in 1994 when he was cast in a low-budget film by Paul Anderson. *Shopping* was universally panned by critics as an incoherent attempt to glorify street crime, and audiences simply absented themselves. But for Jude its significance was much greater, because it was on the set of *Shopping* that he first met Sadie Frost. Given their subsequent off-screen romance and later marriage, their first scene together is hardly one that hints at any sexual chemistry between the pair.

> *'Ever been abroad?' she asks Billy, the character played by Jude.*
> *Just released from a 3-month sentence, Billy replies impishly: 'No. I've been to Durham.'*
> *'What's in Durham?' a nonplussed Jo asks.*
> *'Prison.' Billy replies deadpan.*

Yet, it had enough pretensions to attract the critics, even if only to savage it. Jude, though, was working in productions that were considered worthy of criticism; it also co-starred Jonathon Pryce, whose friendship Jude cultivated.

At the time Sadie was 26 and still married, but had separated from Gary Kemp – singer and song-writer with

Spandau Ballet – with whom she had a 4-year-old son. She fell in love with Jude on the set of *Shopping*. 'Right from the start I knew I was falling in love. I knew immediately that Jude was the one,' she claimed. She also maintains that she must have known Jude in a previous life because they felt so right for each other: 'It was as if we had been happy together in another time. From the moment we met we just got on.'

Sadie's upbringing couldn't have been further removed from Jude's. Both her parents were just 16 when she was born in Manchester on 19 June 1967. Her mother, Mary Davidson, was a ballet dancer-turned barmaid who, like Sadie, always took her spiritual side seriously: for a while Mary worked as a 'healer'. Such healers, incidentally, are bit like witchdoctors in that they diagnose and cure ills by consulting the spirits. She never married Sadie's father, David Vaughan, and between them and their various partners they managed ten children. They were committed hippies and practised such celebrated Woodstock values as free love and the liberal use of controlled substances.

Sadie Frost met Gary Kemp (second from right) when they were working on the video for *Gold*

Vaughan knew Paul McCartney and Sadie often holidayed at his farm on the Mull of Kintyre. It is not known if Sadie was the inspiration for McCartney's catatonic dirge to the peninsular. But if John Lennon had been alive to hear it he'd have immediately renounced peace and love for war and hate.

Vaughan also knew John Lennon and they got on

together like the Rizlas and roach of a well-rolled joint. Vaughan even painted a psychedelic abstract on John Lennon's Rolls Royce, which was his interpretation in oil of an LSD trip. Such was Middle England's outrage over this act of vandalism that it provoked civil disorder in Tunbridge Wells.

In 1994, though, he was sentenced to four years for his militant anarchist activities. Sadie explained at the time, 'He's always spouting stuff, and it provokes people. He doesn't approve of bureaucracy and schools and police, anything that's official.' In the end, the overly casual administration of controlled substances gave him Hepatitis C, which eventually killed him in 2003.

Jude was impressed with Sadie's connection to the Beatles as he revered their songbook. One in particular came to symbolise his intoxication with her – 'Sexy Sadie'. After they began living together in 1994, she expressed concern about his effect on women, which given his womanising past – he assured her many times that it *was* in the past – could lead him up the Primrose Hill, as it were. To reassure her, and to remind himself that his sexy-cad act was only for stage and screen, he had a line from 'Sexy Sadie' tattooed on the inside of his right forearm, reading, 'You came along to turn on everyone, sexy Sadie.'

There is a revealing and all-too-frequently overlooked aside to this tattoo that shows more of Jude's character than he might like. John Lennon had written the song about the Beatles' one-time guru, the Maharishi Mahesh Yogi (the inventor of transcendental meditation). The Fab Four and their entourage had decamped to his ashram in India in the mid-60s to find enlightenment without dropping a tab. However, the randy old self-sanctified

guru was used to rich westerners – not as rich as the Beatles, though – buying his hokum, but not all of them were acquainted with the hidden riders to the deal. One of them was his right of congress to all these white, lubricous young women who were coming to him to 'emerge a better person'.

One of the Beatles' group was Mia Farrow, freshly out of her marriage to Mafia-crooner Frank Sinatra. The Maharishi crept into her tent – they all had luxury air-conditioned tents – to instruct in her in her 'secret sound' but what is really better described as some transcendental foreplay, which as a girl educated at an English convent she predictably interpreted as rape. Mia is renowned for never missing a cue for a bout of histrionics. She screamed out to her sister Prudence, 'This vile, filthy beast tried to rape me…' The Maha by now was 'Ohhh'-ing softy in the corner of the tent and presumably consulting higher powers about what to do.

John Lennon was summoned.

Lennon had already decided that Maharishi was just another conman and this was all he needed to persuade the rest of them that they must pull up tent-pegs and leave. An implacable Lennon confronted the Maharishi who, all innocence and light, asked why they were leaving, to which Lennon replied,

'If you're so cosmic, you can figure it out.'

John then wrote a song about the Maha's ashram at Rishikesh, which had lines like 'Maharishi what have you done, you made a fool of everyone'. Some of the lyrics were obscene and other potentially libellous, so he

eventually toned them down and changed Maharishi to 'sexy Sadie'.

Jude could do better with his grasp of cultural history – there is an irresistible irony in how the tattoo he thought was a loving dedication to his wife's binding sexuality was actually a denunciation of the very weaknesses that were to wreck his own marriage.

Sadie's first flirtation with stardom had come when she was three years old, in an advert for Jelly Tots, but she gave up acting to go to school, ending up at Hampstead Comprehensive. By her teens, Sadie had won a place at the Italia Conti stage school Britain's oldest performing arts school, but she was dazzled by the emerging punk scene and ended up running away to Liverpool where, aged 16, she landed a bit-part as a dancer in a video for the new Spandau Ballet single, 'Gold'. This was when she met and married Gary Kemp.

She became a housewife and mother but she also took up acting again. She'd had a few small screen roles a bit-part in *The Krays* with her husband, a couple of made-for-TV movies, and a role in 1989's *Diamond Skulls*, which was directed by Nick Broomfield who later shot some brilliant documentaries on Courtney Love and Aileen Wuornos. However, despite her bit-part career, when she was 24, she answered the telephone only to be asked by Francis Ford Coppola if she'd like to do a screen test for his new film, Bram Stoker's *Dracula*. She got the part.

She played vivacious young vampire Lucy Westenra, a member of a coven of sexy bloodsuckers. It would become the role for which she was best known. 'For the screen test I stuffed my bra with socks because breast-

feeding had left me completely out of shape and I gave it everything I had,' she recalled. 'I didn't care if anyone thought I was a prat or hated my screen test. I just thought this is my destiny.'

But after filming *Dracula* Sadie didn't capitalise on her new-found fame as much as some observers expected. Instead, she headed back to London to look after Finlay and Gary. But she found her husband boring, especially in bed. They separated in 1992.

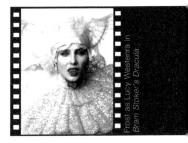
Frost as Lucy Westenra in *Bram Stoker's Dracula*

When Jude met Sadie on *Shopping*, he initially thought she was younger than him. 'She's kind of petite and bubbly, but a powerhouse of inner strength and girly energy,' he said, describing his new love as a 'spiritual woman and a calming influence on everyone'. He was attracted to Sadie's slightly mystical, other-worldly air. He'd found himself stuck in a sex and booze rut that he was conscious was stultifying his development as an actor. He became spell-bound with her looks and personality, and he felt she would stabilise his turbulent private life. They fell in love.

Sadie was much more sophistic-ated than Jude – she was not only five years older but had been married to a big rock star and knew everyone on the showbiz scene. He became utterly intoxicated with her and pushed her to live with him. She held him at bay until he got to know Finlay, but they quickly became an item and did set up home together in 1995.

Years later, when asked about their first encounter, Jude

replied, 'People always say I met her when we did *Shopping*. But what really happened was that we met at work. That's where most people meet, isn't it?'

Although Jude was disappointed in the failure of his first lead in a feature film, he was philosophical. 'There's no point getting up at four in the morning, going to work and being a miserable old shit,' he informed one interviewer. 'I enjoyed making *Shopping*. And I learnt shit-loads.'

Although the film was widely criticised, Jude's love affair with the lens was only just beginning, and his fledgling talent was clearly going to fly very high. Jude himself was conscious of his appeal on screen, and was concerned that the potential path laid out before him – that of the good-looking chiselled-jawed leading man – would lead where he didn't want to go. It was the Cary Grant-Hugh Grant territory, the 'sexy cad' stereotype. Jude claimed once that this was the toughest place for an actor to be, because 'it's actually the most exposed. You're not hidden by a hump or a mad wig or something.' Jude is not in acting to play himself – he is acting to invent himself. Which is a rather different proposition.

Jude wanted a Hollywood career but he didn't want it on Grant-Grant terms. Wiser heads told him that he needed more depth as an actor to conquer the Hollywood hills and, before he was typecast, he stepped back to theatre. His model was Gary Oldman, who had used the stage to hone his formidable acting talents. Jude spoke about wanting to 'dig a little deeper', to explore some of the darker sides on his character. However, what was uppermost on his mind was the risk, the challenge… and where his career has been concerned he has always risen

to the challenge. It was a brave decision that few people and even fewer actors would have taken.

He had never played *Julius Caesar* but he knew the lines from the play:

There is a tide in the affairs of men,
Which, taken at the flood, leads on to fortune;
Omitted, all the voyage of their life
Is bound in shallows and in miseries.

His first appearance post-*Shopping* was in *The Snow Orchid* at the Gate Theatre in Notting Hill. Then a part in John Arden's *Live Like Pigs*, followed by Miller's *Death of a Salesman*, and Jude was keeping well away from the 'pretty boy' roles he so easily could have landed. When a starring role in Jean Cocteau's *Les Parents Terribles* came along, directed by Sean Mathias at the National, he was already well-established in the theatre. This part was a triumph for Jude, who played a sexually inexperienced young man with an Oedipus complex.

Cocteau's directions in his original manuscript were very clear: for the entire first scene of the second act, Jude would have to appear naked in a bathtub on stage. Jude claims that this particular production was the turning point in his career '...mostly because of Sean Mathias' bravery as a director and his ability to seduce out of you incredibly explicit and emotional performances. The nudity aspect of the role was a kind of unpeeling of any fears.' Like all great actors, Jude has a touch of the exhibitionist in him and, as he is not phallically challenged, he took to nudity like a toy duck to the bathwater.

Les Parents Terribles was a huge hit, and Jude found himself nominated for a prestigious Olivier award for Most Promising Newcomer, and a Tony award for Best Featured Actor. But while Jude was working in the theatre, his mind was on his next move in film, and his ferocious work ethic was much in evidence.

With Sadie, Jonny Lee Miller and his other mates, he began planning to set up an independent production company. They would sit in a club – 41 Beak Street, owned by one of the group – throwing ideas around and suggesting stories they had read that could be turned into feature films. They wanted to move away from the blockbuster concept of film to what they wanted to do, and to what they thought the public wanted to watch.

Their first venture was to make a film called *The Hellfire Club*, which would centre on the escapades of a group of 18th century libertarians, started by Sir Francis Dashwood, who engaged in all manner of naughty things such as swinging, deflowering nuns and devil worship. They were very excited about developing *The Hellfire Club*, but, predictably, it remained all talk and was never made. Nevertheless, they were serious about developing scripts, working with other writers, raising funds for productions, even partly financing them themselves if they had to – something that was just not done in 1990s Hollywood.

Meanwhile, Jude upped the pace in his personal acting career. In 1995 he began a repertory run with the Royal Shakespeare Company at the Barbican's Pit Theatre in a production of Euripides' *Ion*, for which he was to win the

Ian Charleston Award for Best Young Classical Actor. But while he was performing at the Barbican, *Les Parents Terribles* had been given the green light to move to Broadway, and Jude had to commute back and forth to New York for rehearsals.

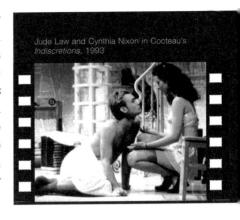

Jude Law and Cynthia Nixon in Cocteau's *Indiscretions*, 1993

Jude was the only cast member invited to reprise his role on Broadway, which was quite a feat in itself as the American actors' union only allowed stars or 'uniquely talented people' from abroad to work in the US. Jude played opposite Kathleen Turner who was chosen to star as his mother and *Les Parents Terrible* changed its name to the more American-friendly *Indiscretions*. But nothing was to prepare US audiences for the cherubic-faced Brit's full-frontal nudity.

'He didn't get out of the bath, give you a quick flash, and then turn upstage,' director Sean Mathias said. 'He did it for real, just dried himself as if he were in his own bathroom at home, so you got to see plenty of him. It was as easy for him as falling off a log.'

One evening, the less well-endowed male members of the cast decided that they had had enough of Jude's stud act and filled the normally warm bath with freezing cold water. He later told talk show host Rosie O'Donnell: 'And so of course, I had very wrinkled... toes.' He also worked the same joke in an interview James Lipton remarked who commented, 'Poor fellow', to which Jude quipped,

'Poor little fellow.' For those of a phallocentric disposition, paparazzo shots of a naked Jude changing at his parents' home in France show that, while he would not clear the shower room, he wouldn't provoke a fit of the giggles either.

Jude won rave reviews for the role and Hollywood's bold and beautiful turned out to watch him. Hollywood was, potentially, an open door. Jude's next move would be crucial.

While Jude was starring on Broadway, Damon had been in touch about the production company they wanted to set up back home in London. They needed a name and it soon became obvious to them what it should be: Nylon – short for New York/London. But when Damon told Ewan, Jonny and Sean the three of them laughed out loud. 'It sounds like we're selling stockings,' Sean said. Between them they decided a simple addition of the word 'Natural' before the Nylon would suffice.

Although Natural Nylon was born in 1995 it would remain just a concept for a while; the friends were still a long way from their first production, which wouldn't hit the big screen until 1999.

While Jude was on Broadway with *Indiscretions*, he found time to make a film *I Love You, I Love You Not* – a quirky number co-starring Jeanne Moreau and Clare Danes. This was shot during the day in New York while Jude appeared nightly in *Indiscretions*. It got mixed reviews, although Jude was invariably exempted from the bad ones.

Still in New York, Jude had gone out on a drinking

to the challenge. It was a brave decision that few people and even fewer actors would have taken.

He had never played *Julius Caesar* but he knew the lines from the play:

There is a tide in the affairs of men,
Which, taken at the flood, leads on to fortune;
Omitted, all the voyage of their life
Is bound in shallows and in miseries.

His first appearance post-*Shopping* was in *The Snow Orchid* at the Gate Theatre in Notting Hill. Then a part in John Arden's *Live Like Pigs*, followed by Miller's *Death of a Salesman*, and Jude was keeping well away from the 'pretty boy' roles he so easily could have landed. When a starring role in Jean Cocteau's *Les Parents Terribles* came along, directed by Sean Mathias at the National, he was already well-established in the theatre. This part was a triumph for Jude, who played a sexually inexperienced young man with an Oedipus complex.

Cocteau's directions in his original manuscript were very clear: for the entire first scene of the second act, Jude would have to appear naked in a bathtub on stage. Jude claims that this particular production was the turning point in his career '…mostly because of Sean Mathias' bravery as a director and his ability to seduce out of you incredibly explicit and emotional performances. The nudity aspect of the role was a kind of unpeeling of any fears.' Like all great actors, Jude has a touch of the exhibitionist in him and, as he is not phallically challenged, he took to nudity like a toy duck to the bathwater.

Les Parents Terribles was a huge hit, and Jude found himself nominated for a prestigious Olivier award for Most Promising Newcomer, and a Tony award for Best Featured Actor. But while Jude was working in the theatre, his mind was on his next move in film, and his ferocious work ethic was much in evidence.

With Sadie, Jonny Lee Miller and his other mates, he began planning to set up an independent production company. They would sit in a club – 41 Beak Street, owned by one of the group – throwing ideas around and suggesting stories they had read that could be turned into feature films. They wanted to move away from the blockbuster concept of film to what they wanted to do, and to what they thought the public wanted to watch.

Their first venture was to make a film called *The Hellfire Club*, which would centre on the escapades of a group of 18th century libertarians, started by Sir Francis Dashwood, who engaged in all manner of naughty things such as swinging, deflowering nuns and devil worship. They were very excited about developing *The Hellfire Club*, but, predictably, it remained all talk and was never made. Nevertheless, they were serious about developing scripts, working with other writers, raising funds for productions, even partly financing them themselves if they had to – something that was just not done in 1990s Hollywood.

Meanwhile, Jude upped the pace in his personal acting career. In 1995 he began a repertory run with the Royal Shakespeare Company at the Barbican's Pit Theatre in a production of Euripides' *Ion*, for which he was to win the

Ian Charleston Award for Best Young Classical Actor. But while he was performing at the Barbican, *Les Parents Terribles* had been given the green light to move to Broadway, and Jude had to commute back and forth to New York for rehearsals.

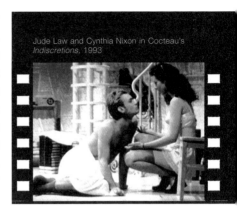

Jude Law and Cynthia Nixon in Cocteau's *Indiscretions*, 1993

Jude was the only cast member invited to reprise his role on Broadway, which was quite a feat in itself as the American actors' union only allowed stars or 'uniquely talented people' from abroad to work in the US. Jude played opposite Kathleen Turner who was chosen to star as his mother and *Les Parents Terrible* changed its name to the more American-friendly *Indiscretions*. But nothing was to prepare US audiences for the cherubic-faced Brit's full-frontal nudity.

'He didn't get out of the bath, give you a quick flash, and then turn upstage,' director Sean Mathias said. 'He did it for real, just dried himself as if he were in his own bathroom at home, so you got to see plenty of him. It was as easy for him as falling off a log.'

One evening, the less well-endowed male members of the cast decided that they had had enough of Jude's stud act and filled the normally warm bath with freezing cold water. He later told talk show host Rosie O'Donnell: 'And so of course, I had very wrinkled... toes.' He also worked the same joke in an interview James Lipton remarked who commented, 'Poor fellow', to which Jude quipped,

'Poor little fellow.' For those of a phallocentric disposition, paparazzo shots of a naked Jude changing at his parents' home in France show that, while he would not clear the shower room, he wouldn't provoke a fit of the giggles either.

Jude won rave reviews for the role and Hollywood's bold and beautiful turned out to watch him. Hollywood was, potentially, an open door. Jude's next move would be crucial.

While Jude was starring on Broadway, Damon had been in touch about the production company they wanted to set up back home in London. They needed a name and it soon became obvious to them what it should be: Nylon – short for New York/London. But when Damon told Ewan, Jonny and Sean the three of them laughed out loud. 'It sounds like we're selling stockings,' Sean said. Between them they decided a simple addition of the word 'Natural' before the Nylon would suffice.

Although Natural Nylon was born in 1995 it would remain just a concept for a while; the friends were still a long way from their first production, which wouldn't hit the big screen until 1999.

While Jude was on Broadway with *Indiscretions*, he found time to make a film *I Love You, I Love You Not* – a quirky number co-starring Jeanne Moreau and Clare Danes. This was shot during the day in New York while Jude appeared nightly in *Indiscretions*. It got mixed reviews, although Jude was invariably exempted from the bad ones.

Still in New York, Jude had gone out on a drinking

session with fellow Brit actor Rufus Sewell. In the bar, Sewell handed Jude a script for a new film about to be made by the BBC. It was a biopic of Oscar Wilde. 'This is a really good script,' Rufus said. 'And there's a really good part for you.'

They finished their beers and left. As Jude walked back to his apartment he leafed through the script, reading over the lines of the character Bosie – Wilde's bratty lover. It was perfect. Stephen Fry playing Wilde! A delight. And Bosie: narcissistic, self-aware, charming, trafficking in his sexual appeal... Jude felt his own character flaws stirring as he saw the chance to be everything on stage that tempted him in his private life.

chapter three

He asked, she gave,
and nothing was denied.
Both to each other
quickly were affied.

Christopher Marlowe, *Hero and Leander*

The mid-90s was a period when film took another technological leap – this time hi-tech special effects – which like earlier advances such as the introduction of sound, colour, wide screen revolutionised the industry.

Computer Generated Images (CGI) replaced animation and allowed used digital techniques a contemporary actor into historical stock news footage or to seamlessly duplicate crowd or battle scenes with just a few extras. However, rather than this cutting costs, film budgets ballooned. Between 1995 and 2005 the average effects budget for a wide-release feature film skyrocketed from $5 million to $40 million. Nowadays more than half of feature films have significant special effects.

Big budgets, however, have proved profitable and together with cable, satellite and DVD sales the film industry is in better shape commercially than it has been for decades. Nonetheless, special effects magic may have massaged the market but the escapism and fantasy that they promote are necessarily at the cost of artistic integrity. Film generally says a lot less than it did or can, which actors like Jude Law both regret and want to change. Eventually he wants to direct and produce, meanwhile he tries to act in films that he would want to watch. Moreover, the success of *Les Parents Terrible* meant that the scripts were coming to him and he chose those that stretched him as an actor and, not least, connected him to the industry's big players

Jude took a leading role in the sci-fi *Gattaca* [1997], which was Andrew Niccol's debut as a director (he scripted *The Truman Show*) and had a cast that included Uma Thurman, Alan Arkin and Gore Vidal. Jude read the full script and not, as many actors do, just his part: he

loved the premise.

Gattaca is like futuristic 1984 but with a little more hope, although not much. Set in the 'not too distant future' it depicts a society that is ruled by genetics not class or, for that matter, achievement or personality. Jude plays a wheelchair-bound ex-athlete with perfect DNA, which a genetically inferior individual wants to buy to fulfil his dream of becoming an astronaut. In a society in which 'geonism' rules he is denied such a chance because of his defective genes. He fails in his quest, but fails nobly. Jude said of the script: 'I didn't know scripts like that still existed. It's harking back to the sorts of films that aren't really made any more, films about the human soul.'

The movie celebrates determination and will over any kind of determinism whether genetic, social or class or religious. Interestingly enough, the line producer was Danny De Vito, who is certainly a living refutation of the case for 'genoism'. One film critic classified *Gattaca* as 'Tech Noir'. It didn't do well at the box office but it deservedly got good reviews, especially Jude's performance.

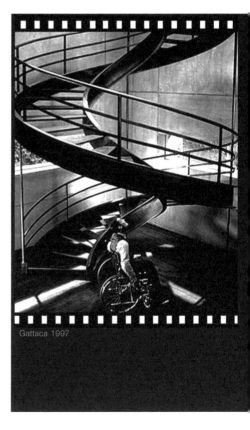

Gattaca 1997

While it was being shot in California in the spring of 1996, Sadie came out to live with Jude. They were unhappy apart and she was now pregnant with their first child, Rafferty, who was to be born in October.

After finishing *Gattaca*, Jude was offered the chance to work with Clint Eastwood who was directing *Midnight in the Garden of Good and Evil*, a film based upon the best-selling novel by John Berendt. Part travelogue, part crime story, it centres on a murder that took place in 1981 when a high-flying gay antiques dealer named Jim Williams shot his street hustler lover, Billy Hanson (played by Jude) to death. The film was shot during the summer in Savannah, Georgia, which was where Jude first met Eastwood. Conscious of his intimidating reputation, Eastwood often asked actors to submit auditions on tape and Jude didn't meet him until they were on location. Nonetheless, when they met, they got on well partly because both were caught up with impending parenthood. Eastwood's new wife, anchor-woman Dina Ruiz, was also pregnant and both husbands were full of the preparations they were making.

Kevin Spacey, who was part of the case, liked to impersonate Eastwood's swagger. Jude recalls how '...one day Clint saw him and he told Kevin "that's the way you walk when you've fucked the world". We were going – wow! Tell my grandson that one.'

However, Jude and Sadie's period together in Georgia did not last long and both were soon off pursuing their respective film careers. Nevertheless, they were ambitious to use their own careers and that of friends like Ewan MacGregor to make their film company, Natural Nylon, a player in the industry. The were united in their belief they

could make movies that not only would satisfy them creatively but also would be commercially successful. Natural Nylon consumed a lot of energy and talk but it was still a long way from being a working production company.

In the summer, Sadie and Jude bought a home in Primrose Hill, which reflected their resolve to build both a family life and, as a number of Nylon's stakeholders lived within shouting distance, a stake in the industry. Generally the area was not settled by the trendy showbiz set but had an arty reputation and feel to it, which reflected their ambitions. Both were adamant about not doing the celebrity circuit, which as an 'in' couple on the rise was theirs for the taking.

Jude was now committed to filming *Wilde*. The actor and comedian Stephen Fry had been cast as the lead because of his mesmeric performance as Wilde in the play *The First Modern Man*. It was a high-octane vehicle for Jude – a huge departure from anything he had done previously and one that, while it put in relief how he often took on homo-erotic roles, could mark him as a lead actor.

After the release of *Gattaca*, the *Sunday Times* took up this theme. It pointed out that Jude seemed to specialise in playing 'broken beauties – men whose physical attributes offer no guarantee against psychological damage o r the ravages of fate. Wildean creations, almost.'

> It is tragic how few people ever 'possess their souls' before they die. 'Nothing is more rare in any man,' says Emerson, 'than an act of his own.' It is quite true. Most people are other people. Their thoughts are someone else's opinions, their lives a mimicry, their passions a quotation. [Oscar Wilde, *de Profundis*]

Jude's stated determination to choose roles on the basis of their psychological interest is clearly evident and, interestingly, many of his most convincingly played characters, before *Gattaca* and since, also have a pronounced homo-erotic aspect. This was explicit in *Wilde*. In an early scene the poet bids his wife goodnight before disappearing downstairs to his young lover where he consummates their relationship. As Bosie and Wilde lie on the sofa together in post-coital bliss, the camera lingers on the contours of the poet's catamite. Bosie says: 'I want everyone to look at us. I want everyone to say "there's Oscar Wilde with his boy."'

The sexuality between the two men is palpable, and a testament to the talent of the two actors. The all-consuming nature of Wilde's obsession becomes evident when this lord of the English language tells Bosie, despairingly, 'I can't command my feelings for you.'

Vanity Fair praised Jude for playing Bosie in such a graphic way, describing it as a 'courageous move' for a young actor. The magazine quoted the actor Ethan Hawke as saying: 'If you were a young male actor and wanted to be successful, it was taboo to play a gay man because people might think that you were gay.' A few years on the rumour mill linked Jude to a homosexual affair with a film director. Of course, Jude also conveys an ambivalent sexuality but as a close friend remarked, 'Yes, you could say Jude is gay but, then, you don't have to be homosexual to be gay.'

Certainly Bosie was a risky part for Jude as it could have pigeonholed him as an arty, sexually ambiguous actor but that risk was for him more of a challenge. He is always looking to extend his range and power as an actor.

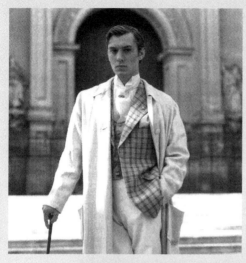

As Bosie, with Stephen Fry in *WILDE*

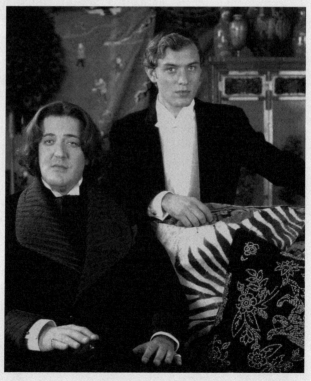

'Anything that boxes you in is a drawback,' he has commented. 'Whether you're known as the strange-looking actor or the scary-looking actor or the good-looking actor. I try to choose parts that move me away from that.'

Jude noted that Bosie was 'interesting' to play as he was 'a younger man in an older man's world. He's the nastiest bastard you'll ever meet in your life. I tried very hard to find his redeeming elements.' Jude takes his work seriously and choosing parts that extend his range as an actor is complemented by striving to get 'in character' of the particular part he is playing. He read up on Bosie, especially the letters between him and Wilde. Generally Jude Law does not use his own experiences and 'emotional memory', as 'method' guru Lee Stasberg put it, to get inside a part, but builds up his own memory bank of how the character would talk, feel and behave. Thus, what the he is doing on the surface is underpinned by psychological layers that he has accumulated through research, experimentation and imagination.

The problem with this is it is a very laborious and intense process that no jobbing actor can apply to each part. Not surprisingly it is when Jude Law gets his teeth into a part that we get his best performances.

When the film was released in 1997, both critics and cinemagoers alike couldn't take their eyes off Jude. Welsh actor Ioan Gruffudd, who played John Gray, an early lover of Wilde, recalled the reaction to Jude's Bosie: 'I remember being in a cinema during the first screening of *Wilde*. And when you saw the first close-up of Jude, the audience just gasped because he was so breathtakingly beautiful. It was great casting and he just played that arrogant petulance so brilliantly.'

Years later, after numerous films, critics would still point to Jude's performance in *Wilde* as one of his best, despite the much higher profile and more mainstream nature of his later films. He won the coveted London Film Critics Circle Award and *Wilde* marked the moment when he went into orbit as a star. Although Jude would choose ever more interesting and challenging roles, he would no longer have to settle for arty Brit flicks that rarely commanded a large audience.

While Jude was in the middle of filming *Wilde*, Sadie gave birth to their son, Rafferty, in London on the 6th October, 1996. Gruffudd remembers Jude discovering the news during the shoot. 'Now whenever we see each other, in LA or socially, he says, "You were there in the car that morning when I found out."'

Jude revelled in being a father: he knew its joy and felt its privilege. There was also the challenge of ensuring that their child was raised in the kind of stable, secure household that his parents had given him: 'That can be the making of you. And it can be the breaking of you. But it's the chance to see this little person grow and evolve and blossom before your eyes.' Both he and Sadie were conscious of how easily their marriage could fracture. Most relationships in their circle did, and sooner rather than later.

Sadie had already gone through one marriage and, as a consequence, the child from that relationship, Finlay, was now being raised between two households. Of course, Sadie's upbringing had been difficult and both her parents were disorganised, if not disturbed. This had left its mark on her – she was very emotional and, as Jude was finding out, a bit of drama queen.

But they were both committed to each other and their family. They also went into it with their eyes open in that they were both aware that as they mixed in hedonistic circles where sex and drugs were part of the scene they had to insulate themselves from it. They explicitly agreed on a 'conventional' marriage: no straying, no celebrity circuit and a commitment to organise their working lives with a view to spending as much time as possible together. Jude made a conscious decision that he would not bring his work home. The evenings were for Sadie, Rafferty and Finlay with life lived in the normal lane – TV, meals, walking the dog...

Sadie decided to put her career on hold to look after Rafferty. Jude recalled the decision: 'She knows the deal and understands when I have to go off somewhere. But it can be hard too, because of the odd schedules. It's a bit of a life of a gipsy, and it's hard to plan anything.' What made this possible was that Jude's fees for a part were now over a hundred thousand. Aside from all the acclaim, Jude was on the way to becoming a rich actor, if not, as it turned out, a very rich actor.

A few months after Rafferty's birth, *Midnight in the Garden of Good and Evil* and *Gattaca* were released. Neither did very well at the box office but *Gatacca* was much better received by the critics. Again, however, the critical reviews tended to single out Jude's performance as the exception.

That year *Vanity Fair* proclaimed 'London Swings Again' and carried a photo of Oasis frontman Liam Gallagher and his wife Patsy Kensit on the front cover, lying under a Union Jack duvet cover. The special issue included features on Terrence Conran, the Spice Girls, Damien

Hirst, Jodie Kidd, and the man who was trying to promote the concept of 'Cool Britannia' more than anyone, Tony Blair. Jude and the other Natural Nylon actors fitted perfectly into this 'new wave'. They were good-looking, charismatic, talented, and above all, British.

Bike couriers deliver-ing scripts were causing a traffic jam outside Jude's agents. But for once Jude was more concerned about his family than his career. They decided to marry rather than just live together and, on 2 September 1997, 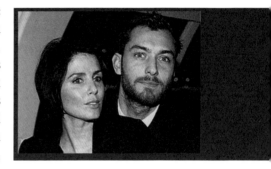 Jude and Sadie married on a barge on the Grand Union Canal in London. Jude even told friends he had thought about a Quaker wedding because he and Sadie liked the idea of all their friends standing in a circle while the blessing took place in the middle with the couple kneeling down.

Sadie was nervous before the ceremony and had bitten her thumb nails to the quick – a habit that she has kicked but lapses back into when she is under a lot of pressure. It was an low key celebration, which shunned the self-conscious glitz of a Cool Brittania IT-couple and was more reflection of th evalues that founded Natural Nylon. Sadie wore a cream Galliano dress lent to her by one of her best mates, the supermodel Kate Moss, and during the service she carried Rafferty on her hip. Guests brought their own booze and dressed down. It was a budget

wedding but the promise of what they represented was reflected in *Harpers and Queen*'s comment that 'there was a flavour of Bogart and Bacall about them.'

Jude was extremely happy with his marriage and genuinely believed that his and Sadie's union would be like his parents'. He knew that she made him a better person, in that he strived for her sake to control his sulks and sometimes ferocious moods. He said at the time, 'She is a terrific family woman who believes the right sort of relaxation can help us all. She has taught me to take things slowly.'

For her part, Sadie loved the security of married life: 'A lot of my friends love being on their own, but I'm into having a relationship. I like to know there's someone there when I'm going home in a taxi.' When she did come home by taxi, it was rarely late – domesticity became their scene and as the lived out their rejection of the celebrity round. Jude described the latter scathingly, 'Full of liggers, and everyone looking over your shoulder to see if there's someone more worth talking to.'

Shortly after the wedding Jude began filming *Music From Another Room*, directed by screenwriter Charlie Peters who précised accurately where Jude stood: 'People in the business knew about him, but he hadn't carried a movie yet. He had been in the moderately successful *Gattaca* and the poorly received Clint Eastwood movie. But while Tom Cruise and Brad Pitt were good movie stars, I think Jude, with his training and skill as a stage actor, belonged in another category as an actor.'

Jude was intrigued by the offer to appear in *Music From Another Room*. He'd never made a romantic comedy

before and as this was an independent movie with a £3m budget it was only going to pay the mortgage never the house. Nonetheless, Jude liked the ordinariness of the film: 'Up until now, I've played a gay guy and a paraplegic. Finally I'm playing a straight boy next door. It's a very simple, very sweet script about an ordinary guy who traces his roots back to America and falls in love. It's an attempt to try and save the romantic comedy genre from the over-sentimentalised nonsense it has become. It's the most commercial thing I've ever done.'

Later, however, when he was securely in the million pus bracket for a part, he said it was the film he most regretted making. In fact, it is a watchable romantic comedy with the droll lines:

> Danny [Jude Law]: I thought you loved me.
> Anna [Gretchen Mol]: Really, what made you think that?
> Danny: Probably when you said you loved me.

Martha Plimpton who is plays Annas sister also says memorably to Jude:

> Danny, look! This filthy, semi-literate yahoo wants to do me. Dreams do come true! No, sure, I want to, right now, right here on the table. Why not? The way that jelly clings to your chin, it's so sexy, look at you. I mean, that pasty, white gut of yours cascades over your belt like water in a dream, what more could a woman want?

There have been worse movies. Jude didn't like it because it didn't stretch him, and he turned in a routine performance. But that was all the director asked him to

do. Later Charlie Peters made some perceptive comments both about film making and Jude:

> You can sometimes get around bad writing, bad directing and other problems, but you can't get around bad acting. And while the movie didn't turn out to be a commercial success, and at the time I had doubts about things, I knew that in Jude's case I could rely upon the acting. He was quite young then. He hadn't had the full bore blast of Hollywood and all it entailed. He was, in the best sense of the word, naive.

with Jennifer Tilly in *Music From Another Room*

He spoke of not wanting to be sucked into Hollywood. He loved London, the idea of doing theatre there (he even spoke of his group of actor friends there) and he loved the notion of raising a family. I thought this was odd (and admirable) for a kid so young, but it was sweet. The best word I could use to describe him is 'earnest'. He was delighted by his marriage and his newborn child, Raffy. He was very close to Sadie's child from her previous marriage, too. He seemed like an older soul in a younger man's body. As an actor he was a thorough professional – always on time, lines learnt, eager, and personable and popular with cast and crew. He even came up with ways to shoot scenes and play them that were a big help to me – he made me look better! I knew Jude would end up being very successful – but only if he wanted to be. It was really up to him.

Sadie Frost with Rhys Ifans in *Rancid Aluminium*

Music was a good showcase Jude – he was in almost every scene. His talent as an actor was obvious to anyone watching it and it certainly wouldn't hurt his career. Meanwhile, Sadie's career was hurting – everything she did turned to dross. She did *Rancid Aluminium* with Rhys Ifans, Joseph Fiennes and Tara Fitzgerald but it just gave the reviewers a chance to let rip... and they did.

After *Music From Another Room*, Jude was adamant that the next film he made would be in London. He agreed to secure a part this time in which stared opposite Sadie, *Final Cut*, a movie produced and directed by Dominic

Anciano and Ray Burdis. The film also starred Ray Winstone and Sadie's sister Holly Davidson.

The budget was practically non-existent and the dialogue was be improvised by the cast, which given the talent was up to the task. Jude said of *Final Cut*: 'Just like going back to school but without rules. It was the most liberating, fulfilling, exciting, weird job I've ever done.'

'I enjoy Ray's and Dom's simplicity,' Jude said. 'The idea of making a film in two weeks – literally roll your sleeves up and fucking do it – that to me is a really interesting and exciting way of making films... as an actor I enjoy getting the chance to work in a big film with big sets and big movie stars, and then when you haven't got a trailer, you've just got your car and just turn up and do it, that's another side.'

He also loved the fact that all the leads in Burdis and Anciano's films were truly nasty people – if incredibly funny with it. 'I really like that,' Jude said. 'I love it that *Jude* behaves badly.' Although the film was ready for release in early 1998, it didn't appear on cinema screens until January 1999 and once it was there it didn't stay very long. Jude would say it was the only film he'd done that achieved its goals because of its flaws. Unfortunately it was the flaws that most reviewers picked up on. But regardless of the reviews, it allowed Jude and Sadie the time to work together.

Sadie also read the writing on the wall: her career in films was falling as fast as Jude's was rising. he had started talking to her friend Jemima French about starting their own fashion label, designing luxury underwear. The partnership, they decided, would be named FrostFrench,

FINAL CUT

Have you ever wondered about your friends?
Have you ever wondered about your wife ?
Jude did. So he decided to find out and now Jude is dead.

ジュード・ロウ. 死亡.

and their first line of clothing, Smelly Knickers. It wasn't what it sounded like: the knickers were impregnated with fragrances, like vanilla, that withstood washing. It was still a year or so from the launch, but the seeds had been sown.

Their taste for domesticity didn't change. 'Before, I was always searching for something, always thinking there was more fun in the next room,' Sadie said. 'But now I know I've got what I want.' And at home, they had house rules: no friends to call after 6.30 pm because that was quality time for Raffy and Finlay. Home time was time for cooking, doing the washing, playing football with the kids in the garden, or sitting in bed, watching TV.

Jude would take Raffy up to Primrose Hill, walking to the top, both of them slightly breathless, to fly their kite together. He was a besotted father, and had even developed a burn on one elbow from constantly having to 'breakdance' for his son in the kitchen; it was one of his party tricks and Raffy would get excited at his dad doing something so freaky as spinning on his arms.

PRIX SPECIAL DU JURY
FESTIVAL DE GERARDMER ÷ FANTASTICARTS

JUDE LAW
LA SAGESSE DES CROCODILES
UN FILM DE PO CHIH LEONG

With his domesticity and happy-ever-after coupledom, Jude also began to show some 'man of the house' aggression. At one time a local newsagent in Primrose Hill shouted at Sadie, as she was flicking through a magazine, 'Are you buying that or what?' She replied sarcastically that she was. He retorted, 'Don't bother. I know about people like you.'

When she told him, Jude rushed round to confront the guy: 'How dare you be so rude to my wife,' he shouted at the newsagent. He wanted to punch him out but settled for boycotting the shop instead.

Jude and Sadie desperately wanted another child but, to allow time to make the doomed *Hellfire Club* together, they decided to wait another year. Natural Nylon still hadn't produced its first film but the company was in a healthy position. It had received backing from some of Hollywood's biggest studios to the tune of £60m but with foreign funding came the necessary relinquishing of some of the control – something the friends had vowed never to do. Jude, Sadie, McGregor and the others desperately wanted to hold on to the reins and so Natural Nylon's first release would have to wait while negotiations continued.

Jude had signed up to star in a film directed by Po-Chih Leong. Leong was a London Film School graduate who had worked for many years in the Hong Kong film industry, directing a variety of movies from slapstick comedies to horrors. *Wisdom of Crocodiles* was his first movie proper in the UK and the film was scheduled for release later that same year. Described as a 'romantic thriller with strong supernatural elements' its co-producer, Carolyn Choa, was married to director Anthony Minghella.

This quirky, low-budget movie was funded by the Arts Council of England and shot at Ealing Studios in eight weeks. Production ended in April, 1998, but the punishing schedule wreaked havoc on Jude and he came down with a bad case of flu. He said it was the hardest job he'd ever done. 'It's been a six day week, in every day from six in the morning till eight or nine in the evening. My character, Steven, is in every scene. And this flu thing has really knocked me out. Altogether it's been pretty gruelling.' *Wisdom of Crocodiles* was another of Jude's films that did badly at the box office and was mauled by the critics who, nonetheless, spared his performance from their broadsides.

'Right now I think I would be overwhelmed if I didn't have Sadie and the kids,' he said at the time. Apart from their determination not to be 'celebrity couple', Jude was working too hard to play the celebrity circuit. He began banging on along familiar lines: 'I can't stand celebrity parties. I've never understood why people go to premieres of films that they wouldn't bother to go and see otherwise.' Jude told the *Sunday Times* magazine that if he was paid the sort of figures that some actors in Hollywood were paid, 'I would only do one film a year.' All he was concerned with, he said, was making films he really believed in. 'And not confusing that with making loads of money or having big hits.'

Yet, even while he was making these statements, the momentum of his career was beginning to trigger a inexorable chain reaction that whether he liked it or not would turn him into a celebrity.

One evening Sadie took Finlay to the Roundhouse theatre to meet the pop band All Saints. Pre-teens didn't know about Jude Law but the All Saints, wow! The paparazzi were waiting outside. Sadie felt as if a swarm of flies were buzzing around her, pestering and irritating her.

It wasn't a problem and she just sailed through them, taking it for granted that they had bigger fish to bait. Previously the paps had always backed off, especially when she had the children with her. However, it was different this night, they began shouting their questions to provoke a reaction but, instead of just accepting her poker-faced look as a refusal to play, they kept up the questions and the snapping.

The rules were changing. Jude was on the verge of

becoming a star and any snapshot, bit of gossip or report, however trivial, about a star is worth money. Some stars court this, others disown it, many exploit it. But it doesn't matter what they do. Once news about them can be sold at a price that makes it worthwhile collecting or even inventing it, then that star becomes part of the celebrity market.

Not even central banks can buck the market. Like it or not, there was now a demand for news about Jude Law and Sadie Frost and their marriage, which those who work in this industry would supply. And it was a fact of life that, however they coped with it, they were both going to have to face.

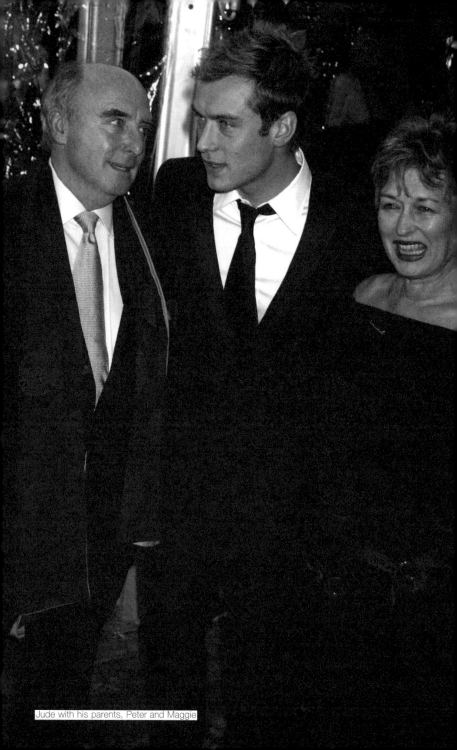

Jude with his parents, Peter and Maggie

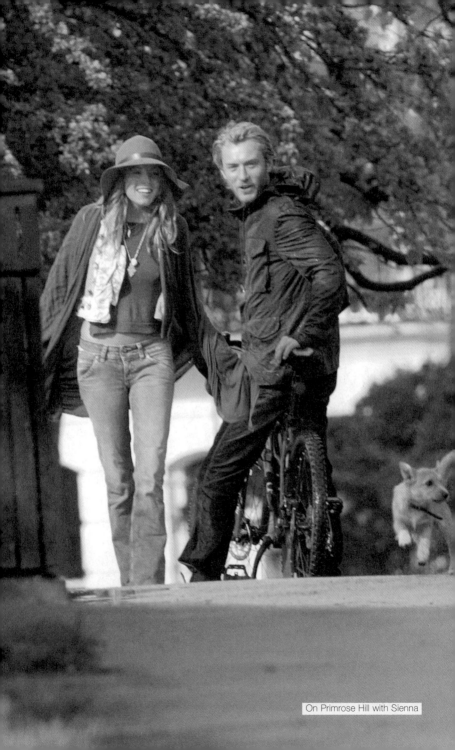

On Primrose Hill with Sienna

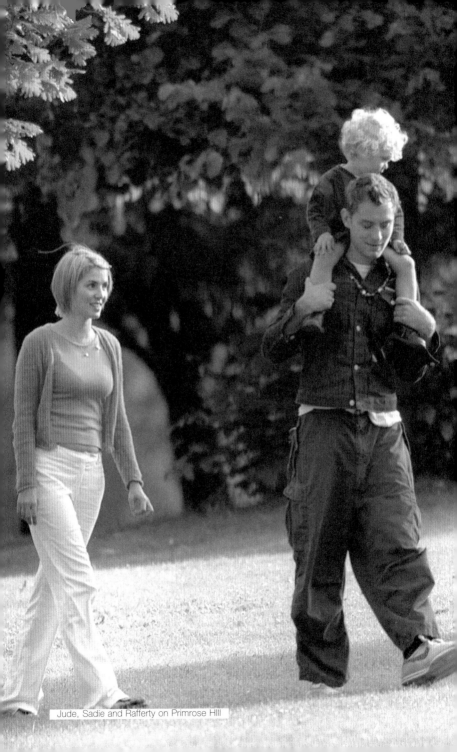
Jude, Sadie and Rafferty on Primrose Hill

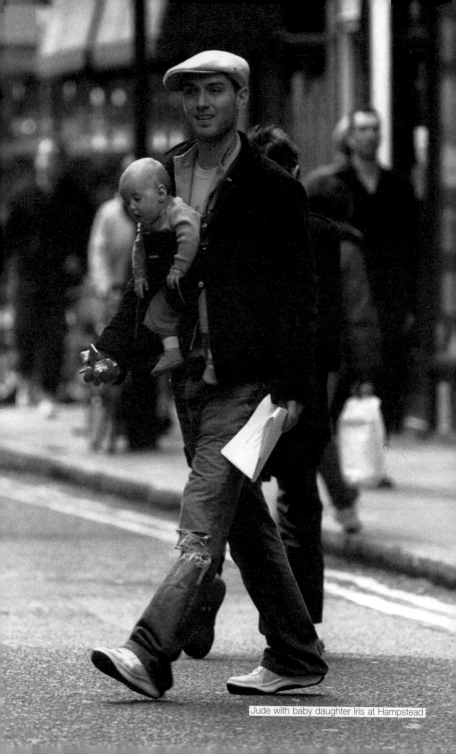

Jude with baby daughter Iris at Hampstead

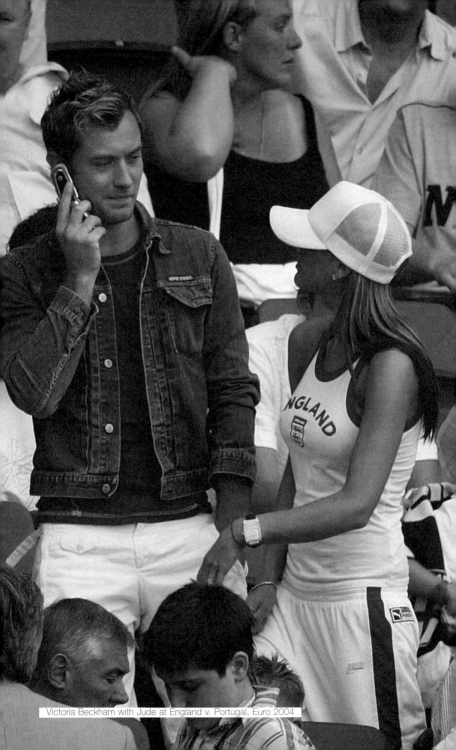

Victoria Beckham with Jude at England v. Portugal, Euro 2004

Playing for charity – Drug Rehabilitation – in an England strip at Brentford FC, 1999

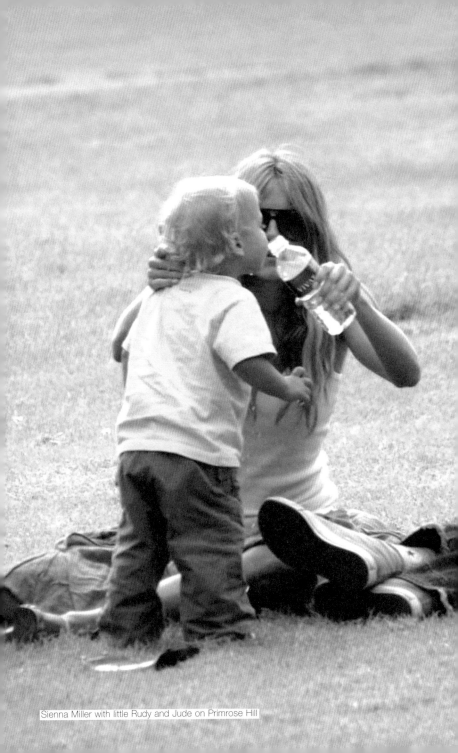

Sienna Miller with little Rudy and Jude on Primrose Hill

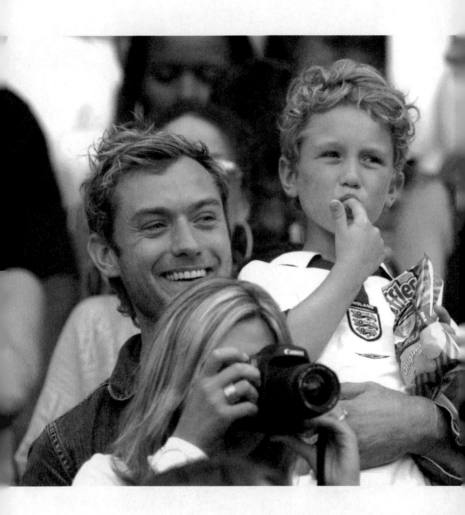

Watching England v Portugal, Euro 2004, Stadium of Light, Lisbon.

Jude and Rudy with Gwen Stefani and Gavin Rossdale

Footy with Raffy at Regent's Park

The Natural Nylon team: Sadie Frost, Sean Pertwee, Ewan McGregor, Jonny Lee Miller, Jude at the opening of *Nora*, in 2000, at the Everyman Theatre, Hampstead

Jude at the launch of Natural Nylon at the The Light Bar in St Martins Lane

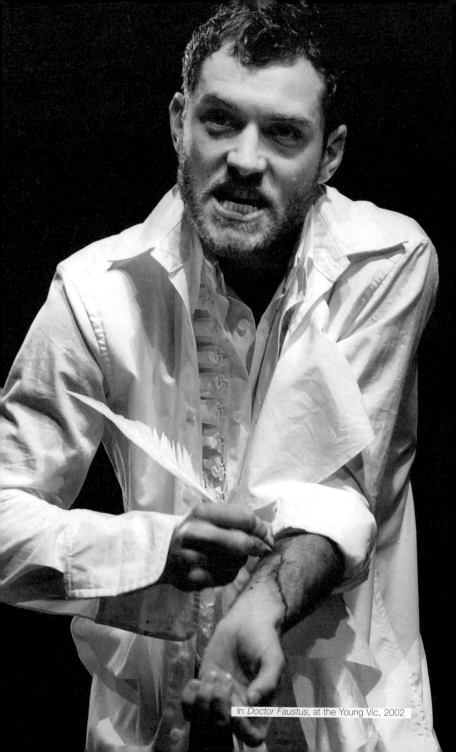

In *Doctor Faustus*, at the Young Vic, 2002

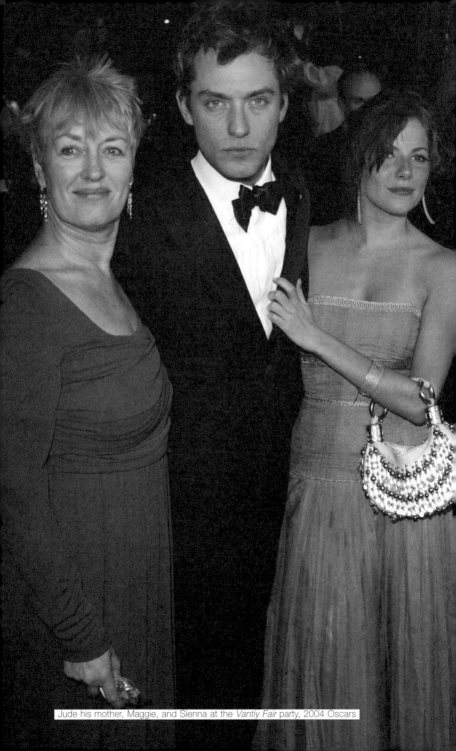

Jude his mother, Maggie, and Sienna at the *Vantiy Fair* party, 2004 Oscars

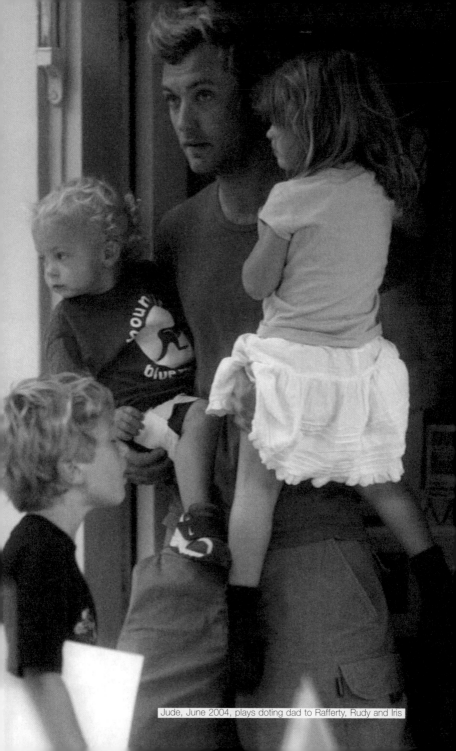
Jude, June 2004, plays doting dad to Rafferty, Rudy and Iris

chapter four
Celluloid Acid

On 19 April 1998, the *Sunday Times Magazine* said that Jude 'was more than just a pretty face'. It was a throwaway line but it was exactly what Jude had been trying to tell everyone since *Wilde*. He was a player.

'The film industry has been built on the illusion of perfect people,' he commented. 'There is a minor revolution going on when people realise that personalities are a lot more complex than the blue-eyed, golden-haired bombshells that strut around most films.'

This was a kind of statement of intent. Jude was now going to act his weight. 'You've got to keep changing the game, just to keep it interesting,' he explained. 'I don't ever want to get to the point where a director says, "Come on, darling, just do what you do." I think the one obligation an actor has is to keep people guessing.' But he acknowledged 'that there may come a time when I'm sick of being worthy, and I'm going to go off and make millions of dollars.'

Meanwhile, rather than cash in, Jude Law was content to keep trying to be 'worthy' by playing what he termed 'fucked up, over-intense characters'. Yet it was grainy, edgy parts that catapulted his star into that elite galaxy of gifted Hollywood heartthrobs who have both looks and talent – ones whom acclaimed directors enter into bidding wars to cast. Yet, his fees were inexorably climbing into the stratosphere anyway, so really he didn't have to go off anywhere to make the millions.

In early 1998 Jude jetted off to Canada to start work on a new film written and directed by David Cronenberg. Although Cronenberg had then directed over 16 full-length movies – including *Videodrome*, *The Naked*

Lunch and *The Dead Zone* – his only real commercial success has come the remake of *The Fly* starring Jeff Goldblum in 1986. Nonetheless, despite the verdict of the audiences, he was widely acknowledged as a fearsome talent with a big mind and one whom the critics, generally, loved.

Jude's decision to work with Cronenberg showed that in choosing directors he was going to put talent before commercialism. He wasn't interested in the big-budget, low-content Hollywood blockbusters, but wanted parts he could really sink his teeth into – roles with a bit of bite.

eXistenZ was typical Cronenberg fare. Futuristic, druggy, blurring the boundaries between reality and virtual reality or fantasy. One reviewer said it was like 'celluloid acid'. Cronenberg had cast Jennifer Jason Leigh (*The Hitcher, Last Exit to Brooklyn, Rush, Single White Female*) in the lead female role. Like Jude, she was always on the search for interesting, challenging, psychological roles, rather than commercial success; in fact, Jude had been a fan of hers for years. Cronenberg, too, had always thought she was a fantastic actress, 'always doing those dark, difficult movies'.

Jude was in chosen auteur company: artists who wanted commercial success but not at the expense of their artistic integrity. It is not that they are driven by some high moral purpose, they are just in thrall to their work. Some idea of what Leigh is like can be gleaned from her reaction to a request from Stanley Kubrick that she stop working on *eXistenZ* in order to re-shoot some scenes in *Eyes Wide Shut*.

Kubrick, of course, wasn't just in thrall to his work he was

obsessed with it. *Eyes Wide Shut* turned out to be his final film but to get what he wanted from Nicole Kidman and Tom Cruise he went way over budget and overshot his deadline. Nevertheless, he then decided that he needed to re-shoot Leigh, whom he'd cast in a supporting role. As this would have disrupted the shooting *eXistenZ*, she told Kubrick to re-cast her!

Jude's choice of role resonated with his private life too. In *eXistenZ* Jennifer Jason Leigh was the dominant partner in the relationship, which at this time mirrored how he was with Sadie. She was the one constant in Jude's life that kept him grounded and focused on his goals. Without Sadie, Jude suspected that he'd drift off into relying on his charm and good looks, leaving his career to lapse into the sexy cad, Cary/Hugh Grant stereotype. His role in the film, then, kept him focused on taking edgy parts and allowed him to explore the submissive/female aspect of his character without ever actually having to admit to it.

Cronenberg admired Jude for taking a role that could taint his image: 'Jude is the receptacle and it's a reversal which was not lost on a lot of American actors who just didn't want to play that role because they felt it was too female... most great actors are dying to play something that is completely not them, and Jude wasn't afraid to play the girl role.'

Perhaps this too was an aspect that spoke to something in Jude: he was prepared to take professional risks to play roles he felt were important and worth bringing to the attention of the public. A role is not real until an actor 'creates' it, and this is what Jude was most passionate about: he was determined to breathe life into characters

that had something to say and was not afraid to put his neck on the line to do it. While most young actors choose more mainstream fare to get themselves noticed, Jude always took the higher and more difficult road to stardom. His eye is always on becoming a both a celebrated actor and a consummate one. Many of his early films were mediocre, but what mattered to him was that they were made and, in the process, he extended his range as an actor.

Sadie flew out with the kids to Canada to be with Jude. *eXistenZ* was filmed in the countryside surrounding Toronto and during filming they stayed in the Four Seasons hotel. When he wasn't needed on set he would spend hours with a local dialogue coach to perfect his Canadian accent. Although he didn't see that much of his family, it was reassuring to him just to have them nearby. Their self-imposed decision to keep work and home separate was difficult, however, as Jude's punishing filming schedule – sometimes 13 hours a day and overtime – meant that the film took over everything. Still, they managed, and it meant that Sadie and Jude could snatch some time together during the long process of shooting.

One evening when they did manage to go out for a beer alone, there was a near disaster. They were in a booth, when Jude left her to get a couple of beers. When he got back to his seat a guy had started to chat up Sadie, he was drooling over her, drunk and incoherent. Jude told the guy to 'fuck off', which was understandable but, given the belligerence of drunks, unwise. He got up and punched Jude in the eye. As Jude was still holding the beers, he couldn't make even a cursory attempt to ward off the blow.

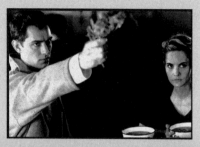

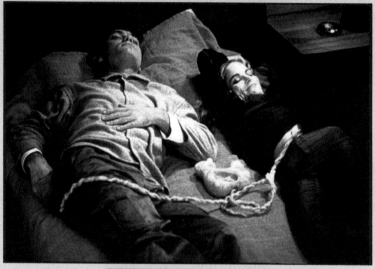

With Jennifer Jason Leigh in Cronenberg's *eXistenZ*

Sadie became hysterical and there was the usual hullabaloo. The drunk was unceremoniously ejected by the bar staff, Sadie calmed down but Jude was left with a corker of a shiner. He was far more concerned about the implications this would have for the shoot than the pain or damage to his ego. Russell Crowe he is not, although Jude did learn to fight back at school and can be a mean tackler on the football pitch.

Cronenberg recalled what happened the next day on set, 'The make-up people really had to work at it, but Jude was mortified because he felt it was un-professional to have got into a situation which could compromise the movie.'

Cronenberg recruited his long-time collaborator Peter Suschitzky as cinematographer on *eXistenZ*. Over the previous 15 years, they'd worked together on eight films. Suschitzky said: 'This was the first time I had worked with Jude and I got to know him quite well and he was very pleasant. The training is very different for British actors. For example, I've never worked with a British actor who you could say was a method actor. They tend to have more technique than American actors and so consequently they're easier to work with – they don't get stuck in the role off-stage, when the camera stops turning.'

Cronenberg said that in *eXistenZ* he was playing with his audience's 'Hollywood-type expectations, but a lot of what I'm doing is denying them those things.' *eXistenZ* was vintage Cronenberg. As one reviewer later described it: 'a film crammed with conspiracy and paranoia, grotesque imagery and weird settings.' And also psychedelic drugs.

As drugs were a feature of the film, when he was promoting *eXistenZ* Jude was inevitably asked the 'had he or had he not' question? Of course, nowadays actors like politicians find it politic to admit that they'd tried it but invariably it was a long time ago and they didn't find it enjoyable enough to keep *inhaling*. As to acid, Jude replied: 'I've done it once. Eight years ago. I had an amazing experience, but I was so strung out and frightened by the comedown and sudden awareness of where I'd been, I didn't want to go there again. Also, I was very aware of an alien form in me and I like being quite clean. I eat organic food. And I was aware of this thing inside me that I couldn't wait to clean out. It was like, "Water, water, fuck get it out of me".'

Jude was on a high during the making of *eXistenZ* . He was working hard in a part that stretched his talents under a director whom he admired, and he had Sadie and his family in the background as an emotional comfort zone. Co-star Jennifer Leigh was certainly impressed with both his acting and his manner: 'He's brilliant, the most likeable, easygoing, genuinely happy guy. It was fun for him to act anxious and afraid in the movie. He just makes you wonder, what is wrong with me that I can't enjoy life so thoroughly as Jude Law?'

After Jude had finished making *eXistenZ*, he and Sadie headed up to Whitby – a fishing port nestled between the North York Moors and the North Sea in England – to make Captain Jack, a seafaring tale with Bob Hoskins in the title role. Sadie was to play a girl who works in a Whitby fish and chip shop who, along with a motley crew, stows away on a fishing boat bound for the Arctic Ocean. It was a true story, gleaned from the pages of a local newspaper, in which Captain Jack attempted to

retrace the path taken by Whitby's Captain Scoresby who travelled to the Arctic in 1791.

This was to set the pattern for their relationship: while Jude was off filming major motion pictures with internationally renowned directors all over the world, Sadie had small parts in small movies shot in the UK. To some extent this fitted in with the responsibilities she had taken on in looking after the two children. The disparity between their two careers would be one of the crowbars that would eventually crack open their marriage.

Meanwhile, in July Jude flew to Italy to film *The Talented Mr Ripley*, directed by Anthony Minghella (*Truly Madly Deeply, Mr Wonderful, The English Patient*). And although he didn't know it at the time, this would be the film that would make his name and put his price-tag per picture in the millions. Minghella was the first high-profile and commercially successful director to cast Jude in a major role. He'd seen *Wilde* and it was Jude's compelling portrayal of the snotty, beautiful, demanding portrayal of Bosie that impressed: 'It seemed to me that Jude's ability to be the object of somebody else's infatuation or obsession was very clear in that performance.' He knew that Jude would be a perfect Dickie Greenleaf.

In addition to Jude, Minghella's 1999 reprisal would star Gwyneth Paltrow and Matt Damon and was, in fact, given the full title: *The Mysterious Yearning Secretive Sad Lonely Troubled Confused Loving Musical Gifted Intelligent Beautiful Tender Sensitive Haunted Passionate Talented Mr. Ripley.*

This could almost read like a description of Jude's own

character. Mysterious and secretive he certainly is, refusing to let anyone see his real self; loving, tender, sensitive, passionate he is indeed, if we can judge from his treatment of Sadie and his children. Nonetheless, he seems to be constantly yearning for something more, as if what he has is marvellous, but not quite 'glittering' enough. He is aware of this and confused because he cannot understand why he is always driven to search for something just that bit better. Beautiful, gifted and talented are words applied so frequently to Jude that they go without saying; clearly intelligent… but sad, lonely, troubled and haunted? Yes, he probably is. Certainly now. Haunted by might-have-beens and guilt, alone and troubled at the prospect that, however successful his professional life, his personal life has turned into carrion for the vulturine media.

Minghella cast Matt Damon as Ripley and Gwyneth Paltrow as Greenleaf's fiancée, Marge Sherwood. Jude said at the time: 'I felt a little in awe of working with Anthony, who had such success behind him and was so well spoken of, and Gwyneth and Matt, who were very much at the peak of their rise. I had to step in and be this cocksure leader of the pack when I didn't really feel that way.'

In awe he may have been of Minghella, but initially Jude was adamant he didn't even want the part as the bratty Greenleaf – that was, until he realised that this character had something special going for him. 'He did what he wanted to do and expected everyone else to do the same,' Jude said. 'If you really like someone… you should want them to be who they really are. But that's a lot harder than it sounds. Because it may not always include what you want them to be doing.'

The character of Dickie Greenleaf seemed so straightforward, and Jude had a habit of shying away from those roles. But then Minghella revealed the darker side to the character. 'He has more interesting, manipulative

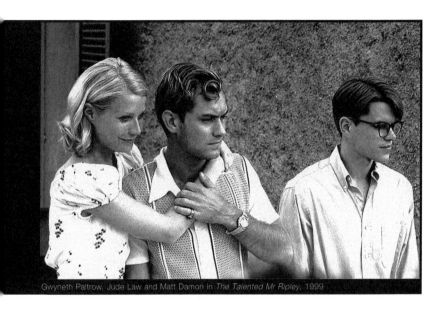

Gwyneth Paltrow, Jude Law and Matt Damon in *The Talented Mr Ripley*, 1999

qualities,' Jude said. 'I'm a great believer that everyone has different colours; the challenge is to look for the lightness in dark characters and vice versa.' Like Brando, Jude loved taking a seemingly straight-forward character and getting inside it so that it became something more than just a role. Dickie Greenleaf's charming, attractive exterior disguised a ruthless selfish-ness and arrogance that made him think he could act as he pleased, and no one would criticise him for it. Perhaps this struck a chord with Jude, who knew how powerful a weapon charm could be when in the right hands. Whatever the reason for it, Jude found in Greenleaf's character facets he could give a lapidary brilliance.

While negotiations over the contract were taking place, Sadie pointed out that the filming would take place over their second wedding anniversary. Jude moved to have a clause inserted in his contract that he could take three days off during the filming to celebrate his and Sadie's wedding anniversary.

Ripley was Jude's smartest move – he stepped up to the plate, didn't strike out, and hit the homer. His American accent was perfect and he had the bratty snobbishness down to a tee. Matt Damon would later say: 'He looks as if he's sculpted from marble. He's a great-looking guy who gives such a good performance you have to be at the top of your game to match him.'

The film was shot mainly in Italy and the backdrop to many of the scenes are the famous landmarks of Rome and Venice – a background against which Jude's classical looks only becomes more pronounced. Ever the perfectionist, Jude was given sailing and saxophone lessons for the role (when the film was finished he kept the saxophone as a memento). Whilst filming the scene in which a spurned Ripley beats Greenleaf to death with an oar, Jude fell backwards and broke a rib on the wooden boat. 'We got a little bit carried away,' he acknowledged afterwards.

Aside from the saxophone, Jude also liked to keep the clothes his characters were wearing when they died. And *The Talented Mr Ripley* was no different: he kept the shirt and Princeton jacket. He would later keep the shirt his character Harlen McGuire wore in *Road to Perdition* after being shot to death, these all joined the clothes Jude's Jerome wore in *Gattaca* when he died in the garbage disposal. This is Jude's own personal Black Museum.

GQ magazine later said Jude had a knack for imbuing his characters – no matter how evil they are – with 'enough magnetism, libido and alluring velocity to make them impossible to ignore… many of the men he plays are thoroughly dislikeable, but that's the way he likes it.'

In the film, Paltrow's character says of Greenleaf: '…the thing with Dickie is that it's like the sun shines on you, and it's glorious. And then he forgets you, and it's very, very cold. When you have his attention, you feel like you're the only person in the world. That's why everybody loves him so much.'

Minghella claimed the film was defined by this description of Dickie's charm. 'That's what capsises Ripley,' he said. *The Independent* newspaper said the same was true of Jude: 'His best performances, with their emphasis on the privileges of class and beauty, make us feel simultaneously seduced and excluded.'

Jude spoke of the challenge of trying to make an audience stick with a character who is so inherently dislikeable. 'And it is kind of nice to try to add a darker side to a predictably nice person. Those are the most exciting roles.'

Sadie joined Jude on set during filming, prompting the rather dippy Gwyneth Paltrow to comment to *Vanity Fair.* 'We were sitting around and all of a sudden I looked over and he was holding the inside of her wrist up to his mouth, biting it in a really sexy, charged way. Their eyes were locked together. I thought, here are these two gorgeous, interesting creatures, and they found each other. It's so beautiful.'

After Ripley had finished, Jude had been working almost solidly for a year. And while the offer of further roles poured onto his agent's desk, he had made a promise to himself and his family that he'd spend some time with them.

In addition he was trying to cut down on drinking and smoking – something he felt he did to excess and wasn't proud of. He began practising yoga each morning in the front room of his home in Primrose Hill and on Sundays he'd head to the park to kick a football around with one of his chums – usually Ray Winstone, sometimes Jonny Lee Miller or Ewan McGregor.

When *Ripley* was eventually released nobody, least of all Jude, was prepared for the measure of its success. Audiences and critics loved it, and the latter more often than not singled out Jude as the key to the film's success. Secretly elated, in public Jude was guardedly level-headed: 'I have a beautiful wife and two beautiful children, and that's my reality. My kids don't know me as anything but Dad and that's what I enjoy most.'

Ripley made Jude an international movie star. He was, as *Hello!* magazine later observed, 'a home-grown star who dripped old-style Hollywood glamour'. This would change his life forever. It was as simple as that.

As 1999 dawned Jude threw himself into his next part. He had agreed to star in a David Lan theatre production of John Ford's 1633 drama *'Tis Pity She's a Whore* later in the year. Meanwhile Natural Nylon was flat out on their first production proper, plus Jude had *Final Cut* to promote. On January 9th Jude and Sadie were at the centre of a unsettling drama on Regent's Park Road near their home

in Primrose Hill. They had been out for a walk when a shaven-headed man blocked the pavement in front of them, screaming 'I'm going to fucking kill you.' Jude grabbed Sadie, pushed past the attacker hustled her back to their home just a short distance away. After she was safely inside he headed back out again to look for the man, finding him a few minutes later threatening customers outside a nearby coffee bar.

The man was swigging from a bottle of methylated spirits in between shouting and screaming at a young pregnant woman sitting at one of the tables. An enraged Jude charged over to him but the police had arrived and they intervened. It was all over as quickly as it had begun, and Jude headed home to an understandably distraught Sadie.

The couple took some consolation in the fact this was a random encounter and not some crazed fan or stalker. Still, it made them realise just how it might be if Jude's career really took off. Celebrities attract nutters.

Sadie had been busy. As her film career began to fizzle out she moved into setting up an off-beat fashion label, which she had been discussing with an old friend, Jemima French, for some time. The pair met in their early teens at a party in Dalston, London, and had stayed in touch ever since. Sadie is like an older, more daring sister, Jemima describes her has having 'clothes pegs in her hair and amazing attitude'. They both came from families that had lots of kids from 'liberal, hippie parents'. They spent a lot of their teens rutting with a variety of uncontrolled men while taking a lot of controlled substances, but Sadie did at least obtain some 'O' Levels. Jemima lasted five months at Whitechapel Art School before she dropped out. Nonetheless, on the hippie trail she lingered in Bali

long enough to have a child and open a little restaurant, then a children's clothes shop, so she developed some business experience. FrostFrench started in Jemima's Primrose Hill basement and moved, two years later, to dedicated premises in nearby Kentish town.

The label's first outing was 'Smelly Knickers', which were vanilla scented panties sold by mail order. Jemima did most of the work but Sadie had big showbiz connections that could always use to attract publicity. Jemima was determined to succeed – as for Sadie, FrostFrench was a distraction from her corpsing movie career.

The company started out of Jemima's kitchen and backyard, financed with just £5,000 from each partner. It was Jemima's task to do the dyeing in vats outside her kitchen and even years later the smell of vanilla makes her gag. At the beginning they worked as a mail-order-only firm before branching out to supply stores like Debenhams, Harvey Nichols... The base of their product line was sexy lingerie but they expanded into sassy ready-to-wear dresses, tops and skirts. 'Together they create an image of a woman empowered by her own renewed femininity post-motherhood,' was the judgement of one magazine, 'often with surprising results.' Whether the expansion is financially viable is still uncertain as FrostFrench tend to pay the bills just as the winding up orders kick in.

By July, Sadie had also signed up to another Dominic Anciano and Ray Burdis movie with Jude called *Love, Honour and Obey*. It was, again, a chance not just to work together but also in London, which meant they could be with Raffy and Finlay.

'You can't be selfish,' Sadie said. 'I don't go out for a drink in the evening. I go home to tuck up my children. I have got too much of a conscience to go out. Because of my work, I've missed too many prize givings and sports days as it is. You have to get your priorities right. Your family is your life; the rest is just work.'

Love, Honour and Obey was a black comedy gangster movie in the same vein as *Lock, Stock and Two Smoking Barrels*. The actors would arrive on set each day at 6 am and Sadie's mother would alternate with a nanny to look after the kids.

Trevor Laird, a London-born actor and veteran of Brit movies such as *The Long Good Friday* and *Quadrophenia*, played Trevor. He told author Alex Hannaford: 'Most of the guys involved were part of the Primrose Hill crowd. Ray, Dominic, Sean, Jonny and Jude all knew each other but apart from Ray Winstone I didn't really know them until I did the picture.

'I remember the first time I saw Jude and when he walks in the room it takes your breath away. The only person who did that before was Greta Scacchi – Jude has that same effect. But he's totally down to earth and loves his kids. Mind you, he's a Spurs supporter but apart from that he's okay.'

At the time of filming *Love, Honour and Obey*, *Notting Hill* hadn't yet been released and so Rhys Ifans wasn't

quite the star he would later become. *The Talented Mr Ripley* had only recently been released and so Jude, too, was still an 'up-and-coming' British actor. And so, perhaps unusually for the movie industry, the cast all felt on a level – that they were all equal. Consequently, Laird described making the film as 'one big party'.

'I think Sadie used to get Jude to go out because he was mostly into hanging around with the kids – they came on set several times and he really was a doting father. The nanny used to come down to look after the baby so Sadie and Jude could be near him. One time we got talking about families and Jude was telling me what a happy childhood he'd had, and I think if you've had such a happy childhood you want to carry that on.'

Laird noted that one nice thing about Jude was the attention he paid you. 'No matter who he was talking to – whether it was me, the production runner or the girl who did the hair – he's very interested in you and makes you feel good,' he said. 'As a contrast some American actors can be so self-absorbed.'

When he wasn't needed on set, Jude would sit in the trailer pouring over car magazines. And when Winstone or Laird joined him, the conversation would invariably turn from cars to football. 'I'm a Chelsea supporter and Winstone's West Ham,' Laird said. 'Jude's Tottenham – so there was always a bit of ribbing but he took it quite well.' Nonetheless, Laird remembers Jude as 'taking his job seriously' and someone who 'works at his craft'.

Unfortunately, after the movie's release at the end of 1999 it was dismissed by most critics as self-indulgent. In his book *Gangster Films*, author Jim Smith noted: 'The

picture's popularity was not aided by the prominence in it of many of the then-fashionable "Brit Pack" of young, hip British actors including "Golden Couple" Jude Law and Sadie Frost.' Despite the poor reviews, the film was good fun to make – more like hanging out with their best friends than working – and Jude and Sadie got the increasingly rare chance to spend some time together.

Of course, working together and spending time together meant Jude and Sadie were increasingly becoming 'public property'. The British media in particular wanted the It couple on the front of magazines. They were the new Liz Hurley and Hugh Grant; the Gwyneth and Brad of the UK. They weren't A-list by this point but they were the best we had, and the long lenses of the paparazzi were already prying into their lives.

'We're not trying to see ourselves as a celebrity couple,' Sadie said. 'It's just what we're getting labelled as.' But whether it was a defence mechanism for fear of over-exposure, it was too late. Jude and Sadie were the new darlings of British cinema.

In keeping with their attitude towards celebrity, they were careful what choices they made with regard to interviews and photo shoots. The momentum of the PR machine had put them in the enviable position of being able to pick and choose. However, you can't manage the paparazzi. And as Jude's star rose, so they both found themselves being dogged by the paps.

Immediately after *Love, Honour and Obey* had finished, Sadie began working on another movie. She had been given the lead role in a film adaptation of the Henry James' classic novella *The Turn of the Screw*, called

Presence of Mind. It was a psychological ghost story, which also featured Harvey Keitel and Lauren Bacal, but the pace of *Presence of Mind* was slow and the film would eventually be eclipsed both in style, acting and sheer horror, by the release of the brilliant Alejandro Amenábar adaptation of the same novel – *The Others*.

While Sadie was away on location, Jude stayed at home and spent time with the kids. David Lan, Artistic Director of the Young Vic theatre had just cast the new production of the 1633 John Ford play *'Tis Pity She's a Whore*, which meant they would spend some more time in London after Sadie got home.

Jude decided that the slackening of his schedule was no reason to take his foot off the accelerator. He saw it as a chance to debut as a director. 'Tube Tales' was conceived initially as a competition in London listings magazine *Time Out*. An editorial asked readers to send in their stories relating to experiences on the London Underground. The best of these would be handed to a group of directors to make one 12 minute film each and the results would be showcased at the 1999 London Film Festival in November.

Jude was asked to direct *A Bird in the Hand* – a playlet about a trapped bird inside a tube carriage which flies into a window resulting in an old man setting it free after the tube emerges from the tunnel. He used hardly any dialogue, telling the story mainly with visuals, imagery and body language. Although he'd moved into the production side with Natural Nylon, *A Bird in the Hand* gave him to opportunity to get behind the camera and be in control for the first time. He loved it. Any actor is at the mercy of the director, and to be able to make the film

what he wanted was a heady thrill for Jude, feeding his hidden ambitions to be in control, not just as a leading actor, but as producer, director, or even money-man.

Jude said he wanted to go for a simple story but with wider connotations. 'The tube is one of the busiest places, but it's also a very lonely place,' he said. 'Everyone is busy going somewhere, but no one is communicating directly. The old man reflects that with his slightly beaten demeanour, but the bird brings him back to life… I chose an old person as the lead because I wanted to show a life in someone's face. You can show so much very quickly.'

The Talented Mr Ripley was due to open in just a few months and starring in Lan's production would mean he was in the city for any publicity commitments and for the opening night. '*Tis Pity She's a Whore* was due to start its run at the Young Vic from the beginning of October, and would run until the middle of November.

Set in Parma in northern Italy, the play is a typical Jacobean love story of unrequited passion, incest, murder and broken hearts. Giovanni [Jude] opens by confessing that he is in love with his sister. 'It kind of shook me up a little bit,' Jude commented about his part. 'It scared me because there's no hiding when you're dealing with Jacobean text. One minute you're sort of kissing the toes of God and the next you're shaking the hand of the devil and weeping every night in front of 400 people. And then sort of being picked apart by critics who say "Oh, I thought he was in the movies now."

'When you work on a 17th century play, it really is like studying. You have to pick it apart to make sense of the Iambic lines and couplets. You have to understand every

nuance. It's nice when life makes leaps in the right direction.' Jude was nominated for the Royal National Theatre's Ian Charleston Award for his portrayal of Giovanni.

The Talented Mr Ripley opened on Christmas Day, 1999, competing with both *The World Is Not Enough* – the new James Bond movie – and the gothic yarn *Sleepy Hollow*, starring Johnny Depp. It more than held its own. Matt Damon was already box office fodder and Gwyneth Paltrow had received the Best Actress Academy Award for *Shakespeare in Love*. And that wasn't to belittle Jude – although *Ripley* would prove his international break-through he was already in the frame as a potential 'next big thing' and definitely one to watch. Critics seemed to be united: Jude was suddenly star material and this was the film that would make his name.

Vanity Fair claimed: 'Carelessly self-absorbed, intoxicated with his own youth and beauty, Dickie was raised by Law's effortlessly vivid performance to the level of iconicity; he became, paradoxically, a premature ugly American – resplendent with all the virtues and vices America brought to its post-war role.'

But *Vanity Fair*'s article was also indicative of everything Jude was beginning to hate about the media. Try as he might to steer his career away from the 'obvious' roles that would centre on his looks alone, the magazine still waxed lyrical about his brazen beauty. Describing an incident during filming Ripley in Italy where Jude was swimming in a pool despite the lightning and thunder around him, seemingly oblivious to the possible danger, the journalist wrote: 'Perhaps water – alternately crystalline and reflective, mutable and fugitive – is indeed Law's element, and perhaps he believed, on some level, that no harm

could come to him while he was swimming in it, that his quicksilver beauty, his sparkling grace would protect him.'

Jude would probably have laughed it off as just more ridiculous, OTT journalese. But it was indicative of what was to come. *Ripley*, while achieving both critical and box office success, would also bestow on Jude the kind of iconic status usually reserved for Hollywood's most glamorous men: Brad Pitt, George Clooney, Tom Cruise. And it wasn't something he was either ready for or would particularly relish.

Reviews also began to comment on the sexually ambiguous characters that Jude was constantly portraying. 'His suggestion of gayness is bound up in an archaic sense of British elegance that has nothing to do with actual sexuality,' one journalist wrote. But here was what set Jude apart from the other beautiful male actors. Although he would end up commanding the same sort of $10m salary per film, he was rarely interested in the type of films they were making. It was as if Jude was far more interested in being recognised as a great actor than going for the obvious money shot.

Interestingly, Charlie Peters, who had directed Jude in *Music From Another Room* the year before, said many people didn't like *Ripley* 'because Jude was more of a movie star in looks and manner than Matt Damon, and they thought Jude should have played Damon's larger role. But they had it wrong – Jude's character has to be someone Matt Damon wants to be; that's what makes the story work.'

A short way into the new millennium Jude's hard work on *Ripley* was vindicated as he was nominated for an Oscar

for his role as Dickie Greenleaf – the ultimate accolade for an actor. *The Talented Mr Ripley* boasted seven Academy Award nominations eventually – as well as Jude's Best Supporting Actor nomination, it was up for best musical score, writing, and two for best costume design and art direction.

Well before *Ripley* came out the writing was on the wall for the acting careers of Jude and Sadie, but now it was cast in stone: he was going to be a star and she would be lucky to keep getting supporting roles in low-budget movies. But *Ripley* changed everything.

For a start there was Jude's salary. He was paid around $745,000 for playing Dickie Greenleaf. Little did he know that four years later he would be commanding $10 million a film. Following *Ripley* he also found he was suddenly being inundated with offers from incredibly influential directors like Steven Spielberg, whose film *A.I.: Artificial Intelligence* was being mooted at the beginning of 2000.

Consequently the quiet but successful life that Jude and Sadie had managed to carve out for themselves was about to come to an abrupt end. 'It's always hard with couples who are actors, because when one is working there's this shift in power,' Sadie told a journalist at the time. 'Jude and I have always alternated, but he's now in a position to do big films, so I can't really say no. My career is important, but I'm not going to put myself first to succeed at all costs.'

And with the limelight firmly focused on Jude now, the effect on Sadie could sometimes be a little unfair. At the beginning of the year a feature article in a British

magazine that was supposed to be a profile of her work was instead headlined: 'SADIE FROST ON JUDE LAW. WHAT IT'S LIKE SLEEPING WITH BRITAIN'S MOST BEAUTIFUL MAN'.

Unfortunately it wasn't just tabloid hacks that were saying this. It was even people whom she introduced to Jude. Sadie knew she was more than just 'Jude Law's wife' but this kind of bitchiness went with the territory. Seeing his wife being denigrated because his career was eclipsing hers, stung Jude: 'I think the thing that kind of grates is the shallowness of people. It is stunning how rude people can be sometimes.'

For his next film Jude wanted to try something different. 'I want to move away from the confidence of Dickie Greenleaf,' he said. 'And the next challenge is to try something else. I want to do something as far away from Dickie Greenleaf as I can get.'

And it just so happened there was an ideal movie waiting just around the corner. French film-maker Jean-Jacques Annaud, who had directed Sean Connery in *The Name of the Rose* and Brad Pitt in *Seven Years in Tibet*, was looking for someone to play a Russian sniper in his new movie *Enemy at the Gates*. And he had Jude in the cross-hairs.

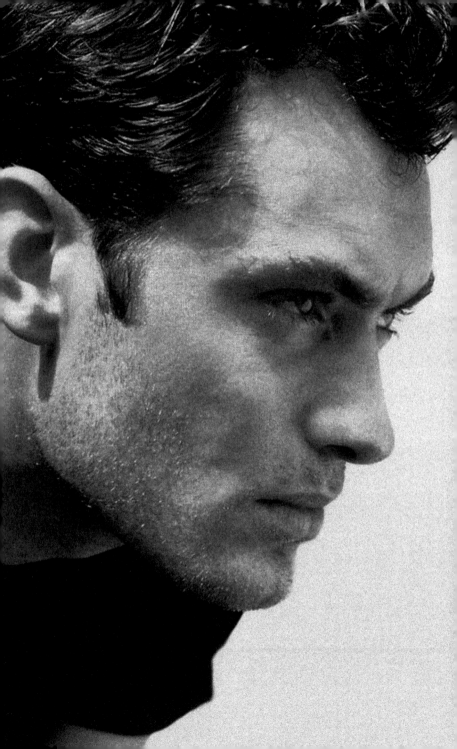

chapter five

Once upon a time there was a piece of wood...

The 72nd Academy Awards were held at the Los Angeles Shrine Auditorium on 26 March 2000 with Billy Crystal as host. Jude was there because he had been nominated for best supporting actor.

American Beauty – the drama directed by first-time British director Sam Mendes – scooped up five Oscars including best picture, best director and best actor for Kevin Spacey.

Whenever the camera landed on Jude, decked out in a smart dinner jacket and bow tie, he was smiling, seemingly pleased to be part of the annual big cinematic event. If a little of that smile was the result of amuse-ment at so many luvvies trying to out-do each other in one room, no one would have guessed. Sadie was proudly sitting beside him in a beautiful ivory halter-neck dress, waiting patiently for the announcement of best supporting actor.

Jude was still smiling even when he was pipped at the post by Michael Caine. Accepting his award for *The Cider House Rules*, Caine said: 'I was thinking how the Academy has changed the phrase from, "and the winner is" to "the Oscar goes to". And if ever there was a category that this applies to most it is this one, because I do not feel like a winner. Jude Law is going to be a big star no matter what happens.'

Later Jude commented: 'I didn't lose. Are you kidding me? Michael Caine mentioned my name on stage! That was the biggest thing that ever happened to me. I thought, "Mum will be so proud".'

Jude's well-groomed look for the Oscars and the

'manicured prettiness' of Dickie Greenleaf were in marked contrast how he had to dress for his next part – Vassili Zaitsev in *Enemy at the Gates*, which was based on William Craig's 1973 book, *The Battle for Stalingrad*.

The film and the book tell the story of how, a year after, the Nazis invaded Russia in June 1941, the German army lay siege to Stalingrad. Hitler had double-crossed Stalin, and his blitzkrieg swept across the Russian steppes in what was virtually a scorched earth policy. The armour of the Master Race raped, pillaged, destroyed and, most of all, killed.

When the Wehrmacht had arrived at the gates of Stalingrad, the Russians stood their ground and halted the seemingly unstoppable armour of the Third Reich. It was the turning point of WWII. The Nazis suddenly looks like they could be defeated.

Jude played the legendary Russian sniper, Vassili Zaitsev – a shepherd boy from the Urals who such was his skill as a marksman once shot a wolf in the eye from over half a mile away. On the banks of the Volga, 'where the fate of the world is to be decided' *Enemy* plots Vassili's deadly and enthralling duel with his German counter-part. In Russia, Vassili's story has the grandeur of which myths are made.

To this day, even when the city is now reverted to its proper name, Volgograd, there is a huge statue of the sniper's face forever carved onto the city's Memorial to the Heroes of the Stalingrad Battle

For the role, Jude read documents about Vassili and studied photographs of his actual rifle, which is still

exhibited in the Volgograd (Stalingrad) Historical Museum.

Director Jean-Jacques Annaud (*Seven Years in Tibet*) points out that Vassili was the perfect hero: brave, cunning, ruthless and yet always noble and honourable. 'We've taken a historical event and tried to understand what happened in the hearts of people who lived through it,' he said. 'We know about some of these characters from the archives and newsreel footage; the rest is open to interpretation.'

The movie had a budget of around $77 million and filming took place over four months in the bitter -15 centigrade of the German winter on the outskirts of Berlin. Most of the time Jude was up to his knees in mud, snow, rubble and dirt. One of the film's key locations was an old army base near the former East Berlin that the Third Reich once used as a staging post to invade Poland.

In the movie Vassili has killed 40 Germans in just ten days, picking them off from among the ruins of the bombed-out city. Russian officer and journalist Igor Danilov, is on the look-out for 'hero stories' to boost morale among the locals and decides to write about Vassili. As a result, the young sniper becomes a legend throughout the Soviet Union.

Enemy at the Gates opens with an intense battle-scene. 'The big charge at the beginning was one of the most harrowing things I have done in my life,' Jude said. 'Many of the hundreds of guys on set that day were Russian. Their grandparents wore the same coats and were shot down at Stalingrad.' The actors couldn't feel their toes, such was the bitter cold. It was also muddy. It didn't

matter whether the cast took a bath, there was dirt everywhere, '…in your pores, under your nails and up your nose'. Jude felt that this is why the film conveys the reality to the battle so well: 'The conditions were certainly a key to why this battle comes over as so gruelling and gruesome and intense.'

To get in character, Jude genned up on sniping. He studied the effect of camouflage, weapons handling and tactics, but when he arrived in Germany for the shoot the stories he heard from young Germans and Russians who recounted tales of their relatives in the battle were far more helpful in building a picture of Vassili. You heard it from the heart, you saw it in their eyes,' Jude noted.

The weather also imposed its own realism on Jude and rest of the cast – knowing about the cold and trying to convey it couldn't really compare to actually feeling near frostbite in one's fingers and toes. Director Annaud was on a knife's edge with crew and cast as both are generally spoiled on location. The inspirational nature of the subject matter and a brilliant script, however, gave everyone involved a sense of artistic purpose, which stilled the barrack room lawyers and shop stewards.

Annaud said of Jude, 'The minute he gets into the costume, he understands the part.' Jude echoed him, 'The answer to Vassili was in his boots. He had these incredible tan boots. And after the first week, I almost couldn't take them off, because they would get so wet and kind of fossilised around my feet.'

He described what he'd learned about sniping: 'The trick of the sniper was to be so well camouflaged that you would never be able to find them and so that was a lot of

The real Vassily Zaitsev in Stalingrad, 1942

their training. They would bury themselves and not move, literally for days. They would go to the toilet in their trousers and eat from the meagre rations they had in their bags, and stay there, maybe just waiting for just one shot.'

For Jude, playing Vassili forced him to dig deep into his acting skills. The part was of a man of few words, yet who carried the fate of the nation on his shoulders. He did not glory in his kills and Jude had to convey the feeling of man who in order to do his duty had to suppress his own natural inclinations not to kill.

Following his incredible strike ratio, Vassili made the front page of the local paper. 'We need heroes,' the journalist Danilov tells him. 'We need to give the people hope.' Vassili pleads with Danilov: 'You've got to stop writing about me. You've turned me into something I never wanted to be. I just wanted to be an ordinary soldier.' Danilov replies that the people need heroes, they need to believe in victory.

To which Vassili replies, 'You've promised people a victory I can't deliver.'

Of course, the parallels are obvious. Jude's stock lament to the press is he just wants to be an actor, not a celebrity heart-throb to millions of women. Even *GQ* magazine picked up on this scene as a 'telling exchange' not merely about Vassili but also Jude:

As Vassily the sniper in *Enemy at the Gates*.

It seems to encapsulate... the actor who just wants to do his job, and give his best on screen and stage, but also has to deal with all the fizz and fluff that goes with that territory.

In order to inject some love interest into the film, Vassili is asked to train would-be snipers, one of whom is a woman played by actress Rachel Weisz. The Russians did use women at the battle of Stallingrad but they didn't look like Weisz. Moreover, Weisz is more than her stunning looks: her mother is a Viennese psychotherapist, her father a Hungarian inventor, and she read literature at Trinity Hall. This was not a combination that endeared itself to Sadie.

What was even more unnerving for Sadie was that Weisz and Jude were scripted to do the obligatory sex scene. 'There is no privacy in war,' Weisz explained.

Sex scenes are always complicated but, in this case, the fact that we were making love as characters who knew that other people were present reminded me of how actors are exhibitionists in some way and how we've all had to train ourselves to block out the other world. Actors are never alone for their love scenes. There are always directors, camera people, sound people, and myriad technicians.'

Weisz did not mention the grips. Grips are always men and notorious for infiltrating the closed set that many actresses insist on for sex scenes.

Curiously enough, such scenes are rarely scripted at the level of detail of other scenes, which can compound the problem of female embarrassment. Of course, most sex

scenes do not move the plot along but are there to underpin the almost mandatory love interest and to titillate the audience. Actresses have to live with it as part of the job but they are always haggling about what they have to show and for how long. Males actors quietly view such scenes as a perk of the job, although the married ones have to agonise about it to their wives.

Vassili's snatched sex with Tania was a problem for Jude and Sadie. They had raised the issue of 'sex scenes' because it is such a well-trodden route into a fling or an affair and talking the issue through was part of their course in defying the celebrity divorce odds and staying together.

The trouble was Jude was less than frank in these bonding sessions. Always he told Sadie how embarrassed and ashamed such scenes made him feel. Yet, as Mae West once quipped: 'Is that a gun in your pocket or are you just glad to see me.'

Sadie felt especially threatened by Weisz who not only has her dark sultry look but is also very bright and well-read. She said to one of her sisters, 'I wish I could put a clause in his contract that he only gets scrubbers as lovers.'

Weisz didn't help matter when she told a journalist how she loved working with Jude: 'He's an extremely gifted, talented actor who happens to be beautiful, but that's not what it's about for him. It's not about the glamour and looking pretty on screen.' The problem for Sadie was that neither she or Jude were intellectuals but he aspired to be one. He was also a sucker not only for a pair of tits but for any woman who came on with ideas, especially if she was good looking.

Sadie didn't know if there was anything between Weisz and Jude but she was tormented by the thought that there must have been.

Enemy was a chance for Jude to play a vastly different character to those he had taken in the past. Playing sexually ambiguous characters had worked for him up to a point, but his bête noire was being typecast:

> *You kind of dig your own grave because if you are recognised as playing something well, then people will remember you as those roles and you're going to be offered those roles.*

His paranoia about this came out in a *Vanity Fair* inteview. He adopted an American accent to mimic a casting director: '*His sexuality is devious! Let's get Jude Law for this role...* I mean, who wants to get on that road? If you build those kinds of fences you're going to find yourself hemmed in rather quickly.'

Vanity Fair also noted that Vassili's struggle to hang on to his humanity as he was 'manipulated and transformed into a national legend... can't help but be seen as a metaphor for the actor's rapid transit down the Yellow Brick Road to stardom.'

One can almost envisage the lecturors in *meeja* studies setting the question: 'Discuss the processes of object-ification by which soldiers become heroes and actors stars.' Ohhhh luvvie...

Shortly after *Enemy*, Jude was asked by David Furnish in a TV interview, 'Would you be comfortable being a Tom

Hanks or Tom Cruise-type?' Jude pondered the question for a moment, gazing out onto the busy streets of London from Furnish's office window before giving his considered reply:

> I see them as movie stars, and I don't particularly consider myself a movie star. In order to go to that level, you've got to want to go there and also want to maintain it, and I've never really wanted to because you've ultimately got to do movies that are surefire hits, and I don't want the pressure… I'd rather have the option to do some smaller projects, do some of my own stuff.

From a very early age Jude had wanted to become a film actor but his interest in production and cinematic technique led to an ambition to be a player in the movie industry. He knew that his only chance of achieving that was through acting. And he was uniquely gifted to become an acclaimed actor – he had Adonis-like goods looks, a talent for portraying other people and, not least, the will to work hard. However, becoming a movie star means adulation and fans who idolise, even worship you not for who you are but for the romantic image conjured up by your acting and its accompanying publicity. During Jude's life, stardom has also come to mean celebrity. Yet, for him and his set, it is just not cool to be a celebrity.

> Fame has been debased by a celebrity circuit that is full of people who are famous only for the attention they have attracted, rather than for anything they have achieved. Second, Jude belonged to a set that is especially keen to disown the hoopla of fame. It's a no-no in his Primrose Hill to revel in attention or, worse, seek it out. There is also a special status attached to

being famous but disdaining its allure. Third, news of the famous has become such a big business with specialist showbiz hacks and paps publicising the private lives of celebrities that the downside of stardom has dramatically steepened. They can't meet their drug dealer or service a groupie without worrying that on Sunday they are going to be splashed all over the *News of the World*.

Jude genuinely detests the accompanying media circus and the increasing invasion into his privacy. The media spotlight has also caught him with his pants down out too often for him to accept it even with bad grace. 'I don't get turned on by money or celebrity,' he told Furnish. 'That's just the way I am.'

But Jude wanted some of the challenges that come with being an actor who carries a movie: the best directors and big budgets. He didn't see himself as carrying blockbusters like Cruise but he could see that the Hanks model had a lot going for it. What he still baulked at was becoming public property. Yet, as the roles he was accepting were getting bigger, he would inevitably have to deal with the associated hoopla. And after *Enemy* was released he was faced with the fact that whatever he did not only him but also his children were fodder for the paparazzi. He was especially irritated in the way they followed him when he took Raffy to school each day.

Jude's latest rationale for feeling persecuted and outraged by the attentions of the media was that while he had chosen to become an actor Raffy had clearly not chosen anything and, therefore, should not be part of the circus. However, he was tiring of small-budget movies and arty directors: *Enemy* had given him a taste of what could be

achieved with decent backing and heavyweight directors. He may have been adamant that even if he couldn't keep the paps at bay he would never buy into the celebrity circuit, but the reality was that once he began to carry big films he'd be a star and therefore part of the circus.

When filming on *Enemy at the Gates* stopped in April, Jude took a few months off. 'I stayed at home and took the kids to school,' he said. 'And played Robin to my son's Batman. He never lets me be Batman. I'm the oversized Robin.'

But Rafferty also wanted his dad to resume his role as a soldier – much to Jude's chagrin: 'When you take your costume off you also take the character off. But Rafferty loved me playing a soldier, so when I got home I had to be a soldier for him, too. We were crawling around the floor and I was, "God, I have to do this at work!" But he didn't understand that.'

Aside, perhaps, from crawling around on the lounge floor shortly after having clambered through trenches in the freezing cold German winter, Jude enjoyed fatherhood. And it was a good thing, too, because Sadie was pregnant again, with the couple's second child.

Natural Nylon was beginning to bear fruit after a few years of delays. One of its first projects, *Psychoville*, was scheduled to begin shooting towards the end of the year, with Jude and Sadie in starring roles. There was also talk of a production about the life of 16th century playwright-hellraiser Christopher Marlowe. As he died in a tavern brawl in 1593, he was denied a memorial in Poets' Corner in Westminster Abbey. Coincidentally, 400 years

later, it was Dr Colin Niven – the headmaster of Jude's old secondary school, Alleyn's in South London – who led the successful campaign for Marlowe to be honoured in Poets' Corner.

In addition, Nylon had also begun developing a film called *Disturbia*, to be directed by Jake Scott and starring Jonny Lee Miller and Sean Pertwee. *The Hellfire Club*, too, was still on the agenda. Jude had also bought the personal diaries of the Beatles manager Brian Epstein at auction earlier in the year. He desperately wanted Natural Nylon to make a biopic of the legendary businessman and had even met with the band's biographer, Philip Norman, to talk about script development.

'I wrote an initial version of the Brian Epstein script, which Law, very politely and quite rightly, decided was in need of further expansion,' Norman told the *Sunday Times*. 'My expanded version was sent to him... and a few days later he phoned me, saying he was "thrilled" with this draft.' *Epstein* would stay on the back-burner for the next two years.

For his part, Ewan McGregor had brought *Nora* to the screen, which would be the first ever Natural Nylon production proper. At the film's opening in 2000, crowds gathered outside the Everyman cinema in Hampstead, north London. Champagne was flowing and Jude, Sadie, Ewan, Sean and Jonny all arrived fashionably late. By and large the critics liked *Nora*, but at the box office it was all body bags: the film took an estimated $12,300 in the U.S.

Not everyone, it seemed, thought Natural Nylon was the hippest film company in Britain. UK *Vogue* ran a spoiler quoting 'London scenesters' as saying 'They should be a

boy band, rather than actors', and 'They're all "look at us, aren't we trendy?" and it's just so naff and smug.'

Sadie Frost and Jemima French

The nastiest comments were saved for Sadie. 'She gets loads of press, and for what? Cos she's married to Jude Law?' Apart from the obvious put-downs, there was one telling point that stung: just because they know how to act doesn't mean they know how to make films.

This stung the Primrose Hill set, as they hoped to make Natural Nylon the vehicle they could use to have complete control over their own films, without having someone else holding the financial or directorial reins. Jude was especially keen on independence and, although he was happy for the moment doing increasingly high-profile films with world-renowned directors, he thought that, when it came to it, his formidable technical knowledge of film would translate itself effortlessly into directing.

Snide remarks aside, the fashion label, FrostFrench, which Sadie had started with her friend Jemima French, had become so successful that they had begun looking for outside investors to help expand the company. 'Things have been a bit hectic of late,' Sadie said of the deluge of orders that the company had attracted.

She was also gearing up for the release of *Presence of Mind* in October. The reviews, however, quickly killed off any hopes that it would be a hit: 'It's hard to recall a more wrong-headed attempt to transfer the author to the screen than Spanish newcomer Antoni Aloy's *Presence of Mind*, a blundering adaptation of *The Turn of the Screw…*'

By the summer Jude was champing at the bit to throw himself back into his career. He wanted to make films that could have a long shelf-life – that people would be talking about in years to come. One script he wasn't about to turn down was *A.I.: Artificial Intelligence.*

Jude had met Stephen Spielberg in LA after filming *The Talented Mr Ripley* and back then he could only hope that one day they would get to work together. When the phone call finally came, Jude was ecstatic. 'I don't let myself get too overexcited, because part of me thinks, "Hang on – if I don't hold it together here I'm going to sound like an idiot and I'm going to blow it." More often than not I'm too busy concentrating on staying cool… He pitched it over the phone and I was all ready to go, "Great! When do we start filming?" but he encouraged me to read the script first.'

Steven Spielberg had just finished writing the screen-play and had decided this was the next movie he wanted to put into production. But it wasn't Spielberg's baby originally. For two decades, Stanley Kubrick had been obsessed with *A.I.*

Jude flew back to London for a weekend during filming *Enemy at the Gates* and had read the script through with the director. 'Just to be in the world of Kubrick and Spielberg combined,' he stated. 'I mean, I would have been happy with either – but to have them both. Of course I was bowled over sideways by the offer. But I also thought,

> OK, I have to take a deep breath here. If Spielberg's asking me, I have to be able to deal with it. He thinks

I can deal with it. So I will deal with it.

Spielberg told Jude how after Kubrick died he felt it his duty to make the film that his friend and fellow-director had had invested so much work. *A.I.* was set in a future in which the city of New York had been submerged by the Atlantic ocean, leaving only the tops of the tallest buildings sticking out from the water. Kubrick had initially procrastinated partly because he wasn't confident that the special effects could convey his vision but Spielberg's *Jurassic Park*[1993] persuaded him that Steven should direct it. The fairy-tale allegory, which is drawn from *Pinocchio*, Kubrick told Spielberg '...is closer to your sensibilities than my own.' Spielberg protested at Kubrick 'giving up one of the best stories he had ever told.' Nonetheless, when he died, Spielberg knew he had to make *A.I.* the way Stanley would have wanted it.

Originally, Kubrick's plan was to make *A.I.* after one more project to which he had committed himself: *Eyes Wide Shut* starring Cruise and Kidman. The couple spent two years filming with Kubrick, but unexpectedly, the director died on March 7th, 1999 – just two days after handing studio executives the final cut of the film. Trying to get from Crusie and Kidman more than they could deliver overloaded his heart.

A year later, Spielberg decided to resurrect the project and using Kubrick's storyboard, he began tampering with the script. It was scheduled scheduled for release in 2001 – ominous because it was the title of Kubrick's only other science fiction movie, *2001 – A Space Odyssey*. 'I am intent on bringing to the screen as much of Stanley's vision as possible,' Spielberg promised, then added, 'along with elements of my own.'

Jude would later say the film was nearer in spirit to *Close Encounters of the Third Kind*, but it had 'that inescapable Kubrick influence. It's undoubtedly a Spielberg film, it's written by him, it's come from his heart, but it does have this interesting kind of influence of the Kubrick spirit.' In fact, because he honours Kubrick's vision, *A.I.* is one of Spielberg's few adult films. He said later, 'I felt that Stanley really hadn't died, that he was with me when I was writing the screenplay and shooting the movie.' It shows.

The film explores the relationship, which fascinated Kubrick, between man and the intelligent machines that he makes for the light it sheds on what it is to be human. The director was aware that after the Bible and the Koran, *Pinocchio* is the most widely read book and there are explicit references to it in *A.I.* The robots or 'Mechas' in *A.I.* are like Collodi's puppet in that they act differently than their maker intended. Indeed, like man, too. When a colleague of the scientist who makes 'a robot child with a love that will never end' questions the morality of such an enterprise, he answers, 'Didn't God create Adam to love him? To which the colleague replies, 'Yes, of course, and look what happened to him.'

playing a cyborg in A.I.

Jude plays Gigolo Joe, a human look-alike robot-cum-stud whose sole purpose was to bring pleasure to humans. Joe knows how humans regard their robots. He tells his alpha-model David, 'They don't love us. They love what we do for them.'

Then, when he is with Patricia [Paul Malcomson] in the mirrored room, Gigolo Joe asks:

Joe: 'Is this your first time…with some-thing like me?'
Patricia: 'I've never been with a *Mecha*.'
Joe: 'That makes two of us.'
Patricia: 'I'm afraid it will hurt.'
Joe: 'Patricia…once you've had a lover-robot you'll never want a real man again… You are a goddess, Patricia. You wind me up inside. But you deserve so much better in your life. You deserve…me.'

To get into character Jude studied Fred Astaire musicals and Frank Sinatra records. 'Steven wanted me to wash myself in really romantic things,' he said. 'Gene Kelly, Rudolph Valentino. The way I walked, the way I sat down – everything had a rhythm.' He studied Valentino, Chaplin, Buster Keaton and Cary Grant, even Elvis Presley for the role.

'Spielberg was far more collaborative than I ever imagined he would be. He really wanted ideas and encouraged people to give their input. Everyone had told me he shoots fast and that was so true – it makes your head spin. I had also been told he is very technical, which I didn't find at all. He was far more of an actor's director.'

Jude got a taste in filming *A.I.* of what it would be like to have more say in a film than he could ever have as an actor, even in a leading role. He also began to appreciate Spielberg's skill in getting the best out of actors, while still leaving them with the impression that they were helping with the direction. Seeing first-hand the power that a director of Spielberg's fame reinforced his desire to one day be in the driving seat of his own films.

Jude's role required that he was clean shaven all over his body. And Jude, because he dislikes shaving, is a notorious stubble merchant. He would arrive at dawn each morning to have his facial hair planed away. He was then spray-painted with latex so his features could be 'buffed up' to a nice sheen. This took three hours and was the only time that Jude was still.

'*A.I* was a roller coaster to make,' Jude recalled. 'Steven is so full of energy and focus and loves working hard. It was quite a surreal experience. I had my feet firmly planted on the ground making *Enemy at the Gates* but in *A.I.* it was anything but. It's not a young person's film, but it's got that dreamlike quality that Spielberg does best.'

Another thing keeping Jude grounded was fatherhood. Iris Law was born on the 25th of October 2000 in California, whilst Jude was filming *A.I.* He opined:

> It makes me feel like I should start smoking a pipe. But parenting has little to do with age; it's about the size of the heart, and patience. One of the happiest sides to my life is the routine I keep at home, being a father, a husband and a regular Londoner.

> Iris is just beautiful. She's also very quiet and I think we deserve a quiet baby because Raffy has been anything but quiet from the word go. With a boy and girl, next comes the white picket fence and a dog, and then I'll be all set.

Jude's children were the cornerstone of his life and they were always wake-up call when he became too intoxicated with the movie business.

Filming on *A.I* finished in November. Actor Ethan Hawke who had starred with Jude in *Gattaca*, made some perceptive observations about Jude at this point in his career.

> The thing I would worry about for Jude is that the Spielberg movie is a hit. It's always fun to see somebody really, really talented who's not just trying to hustle to be the biggest star possible. I hope those doors stay open to Jude. I'm a huge fan of Leonardo DiCaprio, and one of the worst things to happen to any Leo fan was *Titanic*, because now it becomes much more difficult for him to do the kind of work he so excelled at. *Like This Boy's Life* and *Romeo and Juliet*... edgy out-there stuff.

When *A.I.* opened in America on June 28th, 2001, it instantly topped the national box office, taking $29m in its opening weekend. But by the following weekend the figure had fallen by 50% and when it left the US top 30 movies in August in had grossed $77m, which in blockbuster terms – particularly Spielberg ones – was simply 'respectable'.

'It does have a lot of difficult content for children,' Jude conceded. 'But I think that, as someone who's the father of seven, Spielberg understands children are now ready, willing and waiting to listen to darker and more complicated voices. He's not delivering just another super-glossy commercial package. Here you've got a story as real and emotional as *Schindler's List* or *Saving Private Ryan*,' he told *GQ* magazine. 'It's more than simple gratification.'

Movie Gazette gave it seven out of ten, *The Guardian* said

it was a disappointment, *Sight and Sound* claimed Spielberg 'triumphed in his deployment of the vast gladiatorial settings of the Flesh Fair and the neo-Vegas glitter of Rouge City', and *Salon* wondered how a filmmaker as openly emotional as Spielberg 'can ever be at home in a world where emotion has become an entirely synthetic thing?' But judged that whatever was wrong with *A.I.* '...it is not a dismissible film. It's too richly imagined, too accomplished.'

David Cronenberg was more fascinated with what Jude did next: 'If you look at the movies he did before *The Talented Mr Ripley*, and then after, it will be interesting how daring or how dangerous he gets or remains.'

Jude's next choice of role, in fact, surprised a lot of people. It was still in a big budget film, but his character would render him almost unrecognisable. Straight from making *A.I.*, Jude headed over to Chicago to star in *Road to Perdition* alongside Tom Hanks and Paul Newman. It was to be directed by Sam Mendes who was still basking in the glory of his 5-Oscars *American Beauty*.

Perdition was set in the heart of Chicago's Irish gangland of the 1930s. It was loosely based on actual events surrounding a real enforcer working for gangland boss John Looney who is called Rooney in Mendes' film. He was a prohibition-era mobster from Illinois who ran gambling, prostitution, bootleg liquor and stolen car rackets across several states. Eventually, he was convicted of killing an inn-keeper in 1925 and sent to prison for 14 years.

In the film, Jude played Harlen Maguire, a crime-scene

photographer who doubles as a professional hit man in the pay of Al Capone. 'It's set in the Capone era', Jude explained, 'and focuses on the Irish families on the outskirts of Chicago that Capone used for bootlegging. They were the cogs of his business empire. But there are no 'wise guys with Tommy guns' in the film. It is rooted in reality, which makes it more scary in a way.'

'I kind of play... *death* in it,' Jude noted. 'I'm paid to track and kill them. On paper it's a really odd little part because my character just pops up and disappears, but it's important that you, the audience, really feel a threat from him. We wanted to not just disfigure him but give this rodent, a sense of physical power... And this weird gait when he walks. You remember him because he is so threatening.' Jude played the part perfectly. Yellow-toothed and malicious, Harlen Maguire was a ratty criminal who relished his work. Tom Hanks had beefed up for his part, and as Jude was smaller in stature than the American

actor, he decided to forget trying to make his character physically menacing – it just wouldn't work. Instead he would try the opposite: to make him smaller and more rodent-like. And he succeeded. Maguire is frightening and repellent, like a rat he invokes an irrational fear far beyond his threat.

'Sam let me be as freaky and disgusting as I wanted,' he recalled, 'and believe me, I am truly horrible and repellent in this movie. But I thought it looked great. I just couldn't

Paul Newman and Tom Hanks in *Road to Perdition*

bear to look at myself once the filming stopped – I wore a cap everywhere. Maybe I do have this passion to just play weirdos, but I love the challenge. I just figured it would always be trickier to get offered those kinds of roles than the more obvious ones.'

The repellant Macguire did not put Sadie off. 'When he told me about the film I expected him to look really disgusting,' she recalled, 'but when I saw it, he still looked beautiful. He still has those beautiful lips.'

Unfortunately, for Sadie, another woman was of the same opinion. Two years later, a story appeared in the *Mail on*

Sunday, alleging that, in spring 2001, Jude had seduced, while he was working on *Perdition* in Chicago, a mortgage broker named Erica Coburn. When the story broke Jude's Los Angeles publicist Simon Halls stated: 'We did not even dignify that with a response.' However, as the details built up the affair was implicitly conceded.

Erica also moonlighted as an lap-top dancer in Chicago's seedy but expensive Crazy Horse Too. Jude had been out on the pull with another actor from *Perdition* and they visited the club. Jude got excited at Eric's dark, sultry looks and beckoned her over to his table. He still had his Mcguire hat on. When she asked what he did, he told her his name and the film he was shooting. He then left but returned on his own some 40 minutes later and got her over to his table. He chatted her up and asked her to go home with him as he assumed all the dancers were prostitutes. Erica moonlighted as a hooker, as well, but only on her terms. She agreed to meet Jude after her shift and Jude booked them into a nearby hotel.

She'd been cavorting around a pole in high heels and she mentioned that all she wanted to do was just soak her feet. She heard Jude turn on the shower.

> I heard him turn on the shower and I said, 'What are you doing? We're not taking a shower together.' He replied, 'No, you want to wash your feet. He put a towel on the floor and started washing them. It was very sweet. Here was a star caring enough to wash my feet. I was touched.

As there has never been any mention of Jude being especially attentive to female feet, we must assume that he is not a closet foot fetishist and that the feet washing was

neither sexual nor, for that matter, religious. The upshot was they slept together but did not have sex because, as Erica explained, 'Jude was a B-list star to me and I wasn't going to jump into bed with him on the first date.' A-list on Erica's count include stars like Enrique Iglesias!

In Erica's bed, it seems, only A-listers got sex on the first night. Jude is never one to readily take no for an answer, especially when he was already made it between the sheets – he kept moaning about his erection and begging Erica to do something. She wasn't tempted and, eventually, Jude accepted the arrangement and they did *only* sleep together.

However, he kept calling her and two days later she invited him to her place where they did have sex.

> I told him I wasn't on the Pill and I wanted him to use a condom. I don't like the Pill because it doesn't suit my body. He said he did not have any condoms and didn't want to use one. But I had one and insisted he wore it.

> We had sex for an hour-and-a-half. He wasn't great in bed. He didn't care about me being satisfied. He just pounded away like a rabbit. I faked an orgasm. When he reached satisfaction I didn't really notice.

> I wanted to go to the bathroom but he kept grabbing my arm and told me to stay in bed. I thought that strange. When I got up I realised the condom had broken. Was that was why he was so reluctant for me to go to the bathroom? Did he know? I freaked out and said, 'Oh, God, what if I get pregnant?' Anyway, the condom had already broken, so what difference would

it make? Also, making-love with a condom is not satisfying to me. We would have sex three or four times a night.

He could go for ever. He never fully satisfied me but I liked him. He was charming and funny. I thought he was a gentleman. He loved kissing and cuddling. He was very affectionate. We'd see each other regularly and most of the time we were alone we had sex. He had an incredible sexual appetite.

We made love in his bed and occasionally standing up in the bedroom. And when we weren't doing that we would watch movies like *Seven Years In Tibet*. He always wore the hat that he had for the film – even in bed, until it would fall off. His hair had been thinned out for the movie and he was very self-conscious about it.

He told me repeatedly he and his wife had separated. She usually travelled with him, he said, but they were taking a break from each other. I had no reason to doubt him.

However, by chance Erica discovered that Jude was also cheating on her when she visited another nightclub, the Funky Budha, where he was chatting up a number of house girls.

Sadly, Erica did become pregnant but, although Jude took responsibility and assured her that he would look after her, as with Daisy Wright, he didn't. Eventually she had an abortion without any support or even money from Jude. She was bitter about how he didn't even know whether she bore the child or not but she didn't cash in on her story until Jude left Sadie in December 2003.

She claimed in her kiss 'n' tell:

> I'd never have spoken out before because I didn't want to be the one responsible for breaking up his marriage and hurting his children.'

> When we were together, he told me he loved me, but as soon as he moved back to London, I was nothing to him. He broke my heart at the time, but I feel like I had a lucky escape.

> Jude is selfish and self-centred – it doesn't matter who he hurts along the way.

When the Daisy Wright story broke, Erica got in the act again. She commented:

> He'll never be faithful to just one woman. Jude cheated on his wife with me and he cheated on Sienna with his children's nanny. Leopards don't change their spots.

> Jude is someone who acts on his every impulse. He is an addict who gets a thrill out of the chase and seduction. That will never change.

It is interesting the way Erica defined Jude as B-list and didn't tingle; whereas the impressionable Daisy, who viewed him as a superstar, tingled and tingled. It just goes to show that a man's sexual technique is not as important, when it comes to rating his bedroom skills, as how the woman defines his status.

Henry Kissinger once famously observed: 'Power is the ultimate aphrodisiac.' He was wrong. As any frontman in a rock band will tell you it's bragging rights.

Jude enjoyed Chicago not merely for the women but also the part of Maguire. The role was a gift from the casting gods. He was directed by an Oscar-winning Brit who understood the way he worked, and he was playing a character ripe for exploration. It was a role far removed from anything he had done before but one that would mark him out as a definitive actor.

These are actors who whatever the script, whatever the cast, whatever the director conjure up something worth watching. It's a special club and one to which Jude Law was elected very early.

'Jude is an utterly fearless actor,' Mendes said. 'He has no concerns about playing someone quite unlike himself, and here he was a silent, gentle assassin. He can create something utterly three-dimensional and complex without ever uttering a word. He has the ability to deliver something ever so slightly sinister and otherworldly behind the smile and the charm. It's the combination of masculine and feminine co-existing in him that makes him so interesting.'

By 2001, then, Jude was bringing star presence to a film. To do that when performing alongside such heavyweights as Tom Hanks and Paul Newman was quite something. Unfortunately, the scene Jude shot with Paul Newman never made the final edit. But to work with a veteran of over 60 movies was reward enough. Just to sit in front of a screen legend and watch him at work made it for Jude.

And for once, he found himself tongue-tied in front of two actors – Hanks and Newman – whom he revered. 'I was worried that if I opened my mouth, I wouldn't be able to close it,' Jude said.

Newman, 77, was also an old hand at balancing the demands of fatherhood with his movie career. He told Jude not to feel guilty about being busy. 'You can be a good father even if you don't come home from work every day at five o'clock,' he advised.

'He's been doing challenging parts for 40 years,' Jude told *Biography Magazine*. 'He's got an amazing relationship with his wife, and he's got great dignity. That's what it's always been about for me – taking it slowly and sticking it out for the long term.' Jude had found a new role model but while he may emulate him in career it was obvious to everyone that his marriage would flounder.

A friend succintly put what was happening:

> In all walks of life, people rise to the occasion. We all know that but what we forget is that when someone does rise to the occasion he often leaves people behind. Jude was now cutting it with the big players of Hollywood, like Spielberg and Minghella, while Sadie, bless her, was spending her time partying with the likes of Kate Moss and Meg Mathews. I mean it was obvious that something had to give.

There was also Jude's proneness to an outbreak of his leopard spots. He clearly got a bad rash of them when he was playing McGuire and there were probably outbreaks during the filming of *Enemy at the Gate*. But soon he was booked to play the arch-womaniser, Alfie, in a remake of the Michael Caine classic! That was bound to have Sadie hopping around like a cat on a hot tin roof.

Nonetheless, with Newman's comments ringing in ear, Jude returned to London determined to knuckle down to

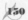

being a faithful husband and a good father, and not to
agonise over absences that he couldn't avoid.

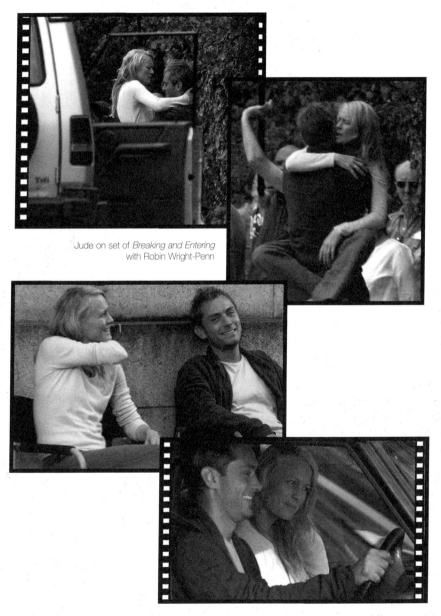

Jude on set of *Breaking and Entering*
with Robin Wright-Penn

chapter six
Leopard Spots

Of course Sadie knew that Jude had been unfaithful: but only in her heart, not with any proof to hand. When she reproached him, he denied, denied, denied – and despite her suspicions she believed him. She wanted to believe him and, after all, Jude is also a very good actor.

Jude immersed himself in being a father to his two children. One of his games was to relate to the children like a silent movie actor. This would get them fired up to make him talk, which of course he would in the end. But when they all went to bed, he'd do the same tease with Sadie. 'There was no mercy,' he said. 'But I think she likes it really.'

Despite Sadie's simmering jealousy, their marriage slipped into a conventional routine of mundane domesticity. Sadie liked snacking on instant Miso soup; Jude would cook veggie loaf for a family dinner. Jude loved listening to Radiohead, while Sadie curled up on the sofa with a book.

To relax, Jude and Sadie had got into Kundalini yoga, which she had picked up from Gwyneth Paltrow. Kundalini – which literally translates as 'the curl of the lock of hair of the beloved' – is a fusion of what is claimed to be the best of the traditional schools, combining meditation, prayer, physical exercise and breathing. Gwyneth promoted it as being a form of exercise that was able to transform lives 'from a state of misery to that of serenity.' Not that Gwyneth is exactly a walking testimonial to serenity. Still, Jude admired her and her husband Chris Martin because like him they rejected the whole celebrity number.

Despite the interrupted nights and wailing babies, Jude

took to the domesticity of home life: he enjoyed cooking, tending the garden, and taking the kids to school. He had accepted that the pattern of his career meant he couldn't be with them constantly, so he was resolved to make the best of them while he was with them. The Newman-esque wisdom had given him a more stoic outlook – that was the way it was and they would all have to live with it. He even told Chris Martin, who had similar problems, 'I think sometimes parents can be stifling, making their children dependent on them, when in fact your role as a parent is to encourage them to feel safe about leaving you.'

By now, Jude had even become friends with Sadie's ex-husband Gary Kemp. 'It took a while though,' Jude commented. 'Christ, dampening fires and all that.' Gary is notorious for being a trifle on the volatile side. 'But we are close. It's all very modern,' Jude claimed, then added about Sadie, 'I still fancy her like crazy. When she's in a room I tend not to notice anyone else.' Of course, in his heart, he knew otherwise but he felt confident that he could keep his affairs contained to when he was on location.

Meanwhile Jude's mother and father were about to emigrate to the Loire Valley where they planned to set up a theatre school. Maggie and Peter had reached retirement age and were looking forward to settling in their little place in the sun.

Although Jude was enthusiastic at his parents moving to France, since they were their resident babysitters, it meant that he and Sadie would have to hire a full-time nanny to look after the children. Up to now they had been loath to do this not least because of the danger it represented to their privacy. They knew from other

celebrity friends that they would have to ask their lawyers to draw up confidential agreements to prevent whomever they hired from selling any information they gleaned from their employment to the press.

Kate Moss with Meg Mathews – part of the Posse's innner circle

In the summer, Sadie and Jude decided to take a break with some of their friends on the Greek Island of Capri before Jude had to gear up for his schedule in the autumn. Danny Goffey, the drummer in Supergrass, was there with his long time girlfriend Pearl Lowe. Kate Moss came along too. Pearl and Sadie are part of the Moss Posse. Danny admitted afterwards that 'everyone was off their faces, and there were really scary times, it was all mental.' What he meant was there was a lot of cocaine and ecstasy being taken, aside from booze and some grass. Sadie, in particular, was going through one of her bouts of jealous despair over Jude's womanising.

It got even more mental when Sadie did a drunken strip in front of Danny and Pearl. She was smarting at rumours of Jude playing away and she became extremely raunchy with Danny. Her figure had recovered from bearing Iris and she was intent on showing Jude that she could be as desirable as his leading ladies.

She broke off smooching with Danny to say to Pearl and Jude, who were agog at the implications of what was happening, 'Come

Kate Moss holding hands with Pearl Lowe

on, we're on holiday. Let's take a break from our partners.' She then hauled the sheepish Danny away to her bedroom. Pearl and Jude looked at each other and were all over each like a rash seconds later.

There were definitely no car keys involved but this arrangement went on until Rhys Ifans (*Notting Hill*) turned up with his then girlfriend Jess Morris and they were also invited to join the wife-swapping club. Rhys told Sadie, 'No way.'

However, the other four continued their romps even when they returned to London. It was only after Sadie read some dirty emails from Pearl on Jude's computer that the whole thing was closed down. She became hysterical and began rampaging through the house, smashing ornaments and mirrors. A frightened Jude eventually calmed her down with pleas and promises that he would never see Pearl again.

The story did not break until some 18 months later when Kate Moss's boyfriend of the time, Pete Doherty, was selling stories to buy drugs. The *News of the World* bought the story from him, then carefully entrapped on tape a number of people who were witnesses to the bed-hopping into confirming what went on.

Both Sadie and Jude denied the story. He instructed libel-lawyers Carter-Ruck who issued a statement trying to contain the story: 'These allegations are completely untrue and highly defamatory and Carter-Ruck have already sent a letter of complaint. Other media are warned not to repeat the allegations.' Most publications ignored the warning and no claim was ever issued against the *News of the World*.

When Jude returned to London he began beating the drum for the Epstein biopic project, which he was developing with Natural Nylon but with no official date set for production. 'We hope to make it next year,' Jude told one interviewer. 'I was intrigued by Epstein because he was the man that threw the party that was the 60s and forgot to invite himself. He had all this glory and yet was lonely and unhappy, and died alone, unloved.'

Jude's ambition was to play the title role, but he wanted to be in control as much as possible. And with his friends from the Primrose Hill set all involved, he knew that even as the lead actor, not the director, he could get his ideas listened to and have a major say in all aspects of the film. 'I think Brian Epstein deserves his page in history,' he said. 'He was an extraordinary pioneer of pop culture. I've got to put on a bit of weight to play Brian, so I'll go off to Italy for a couple of months and eat pasta and drink Guinness.'

The company also announced it going into partnership with London's Ambassador Theatre Group, the second biggest theatre group in the West End – it included the Donmar Warehouse, the Duke of Yorks, the New Ambassadors and Wyndhams theatres... They were intent on upstaging the London theatre scene, with versions of Chekhov's *The Three Sisters* and Marlowe's *Dr Faustus*.

Although Nylon projects were in development, Jude was surprisingly seeing less and less of the friends with whom he had originally set up the company; Ewan had a young family and had been working in Australia for nine months of the previous year; the others all had work commitments too. They were still all friends but their careers were taking them in different directions and, socially, the

Primrose Hill set was gradually coming unstuck.

Jude rather missed the closeness they had all shared, but what with his young family and more and more major films, his life was already overbooked. Natural Nylon was the one thing that really kept them all together, as their stakes in the company were high. They were excited at the prospect of branching out into theatre, particularly as for most of them it was where they felt most at home and where their careers had started. Jude, in particular, was keen to develop theatre productions with the company.

'Times change and life moves on,' Jude noted, 'but Natural Nylon is really important. I like being an actor for hire, and stepping into the universe of Steven Spielberg and Anthony Minghella, but you are not sitting there editing it, plotting and planning it. With Natural Nylon it's a chance for us to stretch our wings.'

Jude kept his diary free for early 2002, so that he could re-charge his batteries and relax with his family. In March, he was booked to appear in a production of *Dr Faustus* at the Young Vic. He knew the part backwards but saw this David Lan production as 'a radical re-think of the old soul-seller'. Faustus is one of the most complex characters in drama and Jude delighted in exploring the twists and turns of his mind and character on stage.

Jude has also been approached by Robert DeNiro, over a possible movie about a Yale graduate sent to England on a fact-finding mission for the CIA. In the end the film was never made but when Jude finally met DeNiro he was, predictably, star-struck. One day DeNiro left a message on Jude's home answering machine and Jude decided to leave it there so he could play it to friends.

Although Jude was capable of being as over-awed by the big Hollywood names and could react like any star-struck fan, when he was the object of such adulation he would not credit it, would define it as unworthy or inappropriate. He has never come to terms with his contradictory behaviour.

His hands-off game with the press continued. Around this time, in a *Washington Post* interview with Jude, a journalist set the scene: 'Holed up in a suite in the Essex House hotel facing Central Park, Law is protected from the rest of New York by a gaggle of studio publicists, his own entourage of fellow Brits, and one unobtrusive security guy… [Jude's] hair appears to have been carefully tousled.'

Despite having a growing awareness of his own public image and how it was best marketed, Jude claimed he didn't read his own press. '

> I just think it would be a bit self-indulgent to read about myself,' he claimed. 'I have no interest in reading profiles and articles and interviews…I'm not really interested in the hype that's been created.
>
> If you're fighting people trying to intrude into your life, you can be seen to be contradicting that by doing press or covers. I would argue that one is on a professional level, the other is encroaching on private life, but you sometimes feel like you're fuelling their argument.

Jude tends to go round and round the same block when he gets on this topic. With a bit of encouragement, he even starts psychobabbling: 'All it really does is highlight your basic insecurities. More often than not you're so

busy trying to cope with the attention, or escape it, that you don't ever wonder why you're actually getting it. I wanted to be an actor not a sex symbol. It was not my goal to become a star...'

A lot of this courts the very attention he claims to detest. It is a simple fact of life (and of the press), that when someone claims to want privacy, everyone assumes that they have something to hide. It's called reverse psychology. By constantly reiterating that all he wants is to be left alone, Jude is in fact attracting the very attention he claims to despise, as everyone is waiting for the skeletons they assume he is hiding to pop out of his closet, waving. And, of course, with Jude from time to time they do.

There are plenty of stars about whom the media knows very little, and whom they no longer bother to pursue. Jonny Depp, Kristen Scott Thomas, Daniel Day Lewis, Robert deNiro all prefer to keep their private lives private, and have succeeded in doing so. But they have succeeded not because they constantly tell the press to leave them alone, but because they conduct their lives in a manner that gives the press little to go on. No arguments in public, no messy undignified break-ups, no high-profile affairs, no rising to journalists' bait.

They promote their films, they give their interviews, they are happy to talk about themselves as actors. But they will not discuss their private lives and, more importantly, nor do they go on a moral crusade when press intrusion occurs. Jude, despite citing Day Lewis as one of his greatest inspirations, can't seem to follow his example.

It is misplaced to assume that he can conduct himself as

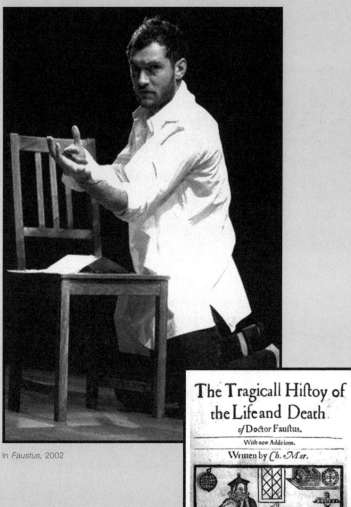

In *Faustus*, 2002

he likes without anyone finding out and revealing it, that just because he tells the press to leave him alone, they will do. Rather than trying to force the media to leave him alone, he should act in a manner which will make them stop of their own accord. It can be done, and is done by those with a more realistic outlook.

In November 2001 *The Sun* ran a photo story of Jude taking Raffy out for a walk, seemingly unaware of the prying lens. 'Five-year-old Rafferty threw a wobbly and his dad had to carry him home in Primrose Hill, North London,' the article continued. 'Well, at that age kids can be a Law unto themselves.'

This set Jude off again. This time he had the kids to help him up on his high horse. He railed against not being able to walk up Primrose Hill without snappers following him. 'You start to think, if a car was to hit me…they would be taking photos of me, not helping me.'

'I'm happy talking to a certain degree about work,' he told *Arena* magazine before he began psychobabbling. 'This is a part of my job…but I don't know who the fuck I am; I'm still trying to figure that out, so I'm not going to reveal an inner working that I don't know myself. I am certainly not going to work out who I am and what I am in public.' He kept banging on:

> Gossip is a very British thing. There is a lot of gossip, a desire for tabloids. The media might set Sadie and I against one another, but we've never really been competitive. Sadie's got so many other things going on. She develops a lot more stuff than me, she writes more than me. She's got another company, a clothes company. She's also had three children in 11 years. If

you look at it individually, she's living a completely different life to me, though, thank God, we're linked. What is it Ginsberg said? You know, I am not 'Jude Law', I am me. 'Jude Law'...is the public persona and that isn't really me. I'm me.

We don't know what he thought about *Time Out* proclaiming that 'he glares into cameras, moving and still, oozing an omnivorous, feral sexuality. Adder-hipped and puff-lipped, he possesses a beauty that seems almost fanged.'

While Jude continued pulling in the big names, Sadie's film career had stalled; she was devoting nearly all her time to FrostFrench and to her family. There was talk of a role in US medical drama series *ER* which would have raised her profile, but it never materialised. And by March, 2002, she and Jude announced they were expecting their third child in August.

'I don't think Sadie and I ever kind of lay in bed on a Sunday morning thinking, "OK, let's have children,"' Jude announced. 'It just happened. I think they've come to save me. Because of what they bring, how they demand the truth, demand responsibility.'

Whenever Jude's leopards spots starts itching he instinct-ively reverts to proclaiming his belief in commitment and faithfulness. There is a telling Freudian slip, however, in his *Arena* comments about him and Sadie: '...she's living a completely different life to me, though, thank God, we're linked.'

Shortly after the announcement, Jude returned to the stage for his latest role as Dr Faustus at the Young Vic, his

first theatre role since *'Tis Pity She's A Whore* in 1999. Surprisingly, considering the mammoth wages he could now command in the movie world, he would be working for £287 a week – the minimum wage fought for by acting union Equity.

Faustus was one of the best received plays of the year. One critic said Jude delivered his long passages, many of them in Latin, '...with such venom and verve that he would actually forget to breathe'. Jude laughed, 'People on the front row complained that I was gobbing on them. But you know what? If you are not feeling it, it won't be convincing.'

The production wasn't without its hiccups. He had to cancel a performance early on after injuring his knee. A month later after cutting his hand on stage he was forced to cancel three performances. The success of Faustus also set off some serious negotiations about bringing a story of the playwright's chequered life to the silver screen. Johnny Depp was mooted to play Marlowe and Rachel Weisz read the script with a view to playing a part. Her verdict: 'It's dirty as hell. A real antidote to *Shakespeare in Love*.' But in the end, due to other work commitments and funding problems, *Marlowe* never came to fruition. It's not known what Sadie had to say about Jude playing with Weisz again, but one insider claimed she 'was very, very Frosty' at the suggestion. In truth, Natural Nylon was beginning to come apart at the seams.

By the end of the year Ewan would leave the firm due to pressure of his own film career. And Damon Bryant – the business brains behind the project – would also fly the nest, to set up Sonnet Pictures. This was the final straw for Jude and, while on paper he would remain a part of

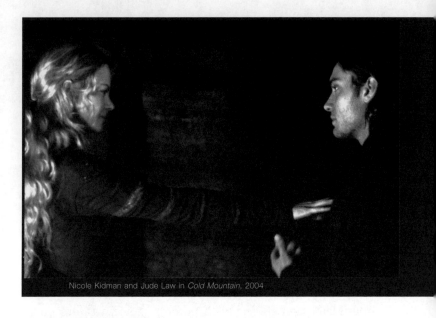

Nicole Kidman and Jude Law in *Cold Mountain*, 2004

Natural Nylon, by the time Ewan went he was no longer a player. It was such a long way from the hype at the beginning when one of Nylon's heavyweight backers said this is '...what film-making is all about: a talent-driven, contemporary, hip environment that generates the best projects'. However, Jude with Sadie quickly set up another production company – Riff Raff.

On July 8th, Sadie accompanied Jude to the New York premiere of *Road* to Perdition. The reviews were good and this was mirrored in the box office – $80million. Jude's charismatic Maguire led to a flood of new offers, including, in Augus, the lead role in *Superman vs. Batman,* which destined to be another Hollywood blockbuster. He was tempted but declined when Warners insisted that they wanted him to contract for any sequels, too. Meanwhile, the protracted negotiations hexed the project and it was shelved.

Jude's eye was set, however, on Anthony Minghella's next movie, *Cold Mountain*. He hadn't worked with Minghella since *Ripley* but in the intervening four years they had formed a mutual admiration society. There was little doubt that he would want Jude in the film. Minghella cast Jude opposite Nicole Kidman.

Jude had read charles Frazier's epononymous novel twice and was inspired by the story of Iman, the wounded deserter from the American cvil war, who embarks on a heroic trek across the South hunted by both sides to reunite with his great love, Ada. Inman's part was scripted with minimal dialogue; much of the sotry being told visually through Minghell's atmospheric shooting and the body and facial expressions of Jude. He described the part: 'It was about finding someone truly at the end of their tether, someone who feels that they're damned.' It tested his acting abilities to the limit too.

Minghella understood the challenge: 'My dialogue with Jude was not "Can you play this role?", of course I knew he could. It was whether he had the will to endure what anyone playing Inman would have to endure.'

For the part Jude grew an unkempt beard and he developed an irritating habit of stroking it pensively while talking.' Sadie hated it but it threw the paps off the scent as they didn't recognise him.

In playing Inman, Jude was stepping up to a higher acting plateau. Could he – in the words of Minghella – 'jettison the slightly false modesty about what you could do in a film?' By taking a part that involved very little talking, Jude was deliberately depriving himself of that most valuable commodity in expressing emotion – words. He

was almost entirely relevant on his body language and, when matched with such huge Hollywood names and talented actresses as Nicole Kidman and Renee Zellweger, the bar was set at brilliant.

The movie's battlefield scenes, which were shot first, were filmed 90 miles south of Poiana Brasov in the country's capital, Bucharest. And it was here that Jude flew into in early July to begin shooting. But his welcome at the airport wasn't quite what he'd anticipated. He had been chaperoned into a waiting Land Rover to take him to his hotel, but just as he was climbing in, a man began shouting at him and threatening him.

Promotional Stills from *Cold Mountain*, 2004

In a bizarre set of events, Jude had found himself in a punch-up with a local politician. Senator Dinu – one of Romania's richest businessmen – recognised the Land Rover as his brother's and assumed that Jude had stolen it. When Jude stood his ground, the enraged senator begun throwing punches. Jude's bodyguard separated the two and explained that the car had been hired. A day later Patriciu discovered his brother had indeed sold the vehicle to a rental company. There were apologies washed down with freebie cases of wine.

Jude stayed in the Marriott hotel while he was filming. In the morning he'd work out in the gym, run around the hotel car park with a personal trainer or swim in the hotel pool. To prepare for the part, he pulled logs outside and pushed a huge tennis court roller around. In a few days he would be enduring an even more punishing regime: dragging himself through boggy mud and snow, trudging endlessly across rough terrain at dawn, wading through swamps... But there were compensations: it was a big budget film, his fee was over million sterling and, not least, he was playing opposite Nicole Kidman.

In the early part of the shoot, Jude's children Raffy and Iris were on set most of the time as Sadie's younger sister Holly Davidson had flown out to help take care of them. But after they left rumours began circulating that Jude and Nicole Kidman were sleeping together she left. Robin Mullins, one of Jude's fellow actors in *Cold Mountain* recalled how the rumours began:

> It started over at a barbecue party for the cast and crew. Jude was dressed so elegantly – black sweater, white t-shirt and jeans. He was always so nice – he had this boyish flirtiness that he didn't just reserve for one

person. Everyone got that energy and attention from him.

There were all kinds of nice looking men and actors – but of all the faces, his was the one that just shone out. He's not just very handsome, he also has this aura about him.

We were in a room and Jude, Anthony and myself were talking about the North Carolina accent, which Jude was trying to perfect. Mine probably would be the closest accent to the mountain accent. So they were all listening to me talk and Jude would mimic my accent.

But I knew he was trying to get to talk to Nicole because he'd never met her before. He was looking over at her and when they finally started talking I upped and left.

Eventually there was a big barbecue outside and people were either sitting at a huge table or dancing and singing. Jude and Nicole were talking and laughing at the table. It was no big deal. But some people's eyes obviously saw it differently.

Despite there being 30 cast members at the party, news that Jude and Kidman were acting 'closer than friends' took a while to got out. The press didn't get hold of the story until after filming had finished and when they did, Jude went on record denying an affair and Kidman successfully sued two British newspapers for printing false accusations. According to Mullins:

They were just getting to know one another. And some-body turned it into something it wasn't, but that's something you have to put up with if you're that famous.

Someone there saw some money in that. I don't know how much money they got in the end. But it was ridiculous – there were all kinds of people at the party and everyone was just having fun. Jude was so boyish. He was not conceited, selfish or self-centred. He had this air of fun about him.

Living in the mountains of Rumania for such a long period of time gave Jude ample time to think. He would spend his spare time walking in the woods and climbing trees. It gave him a peace of mind he rarely found in the hustle and bustle of London life.

However, he soon had to leave the quiet of Rumania to head over to the states for a bit more filming in Virginia. It was while Jude was filming here that he got the call. Sadie was about to give birth to their third child.

On the 10th of September, Jude grabbed his bag from the hotel and leapt onto the next plane home. Sadie had been at home in Primrose Hill, with her friend, Kate Moss, when she had gone into labour.

Sadie was concerned Jude wasn't going to make it back from the States in time. But he did. Rudy Law was born five weeks prematurely in a north London hospital that night. He had taken everyone by surprise – not least Sadie – and she was told by doctors she would be staying in hospital for a few days whilst they monitored his progress. Rudy weighed just 5lbs 5ozs. But Rudy was going to be okay...

However, cracks were beginning to show in the Law's New Age household. Reports began to surface in the press about Jude having a bust-up with Minghella over

paternity leave from *Cold Mountain*. Sadie had developed acute post-natal depression, which put further claims on Jude. Then, Sadie's father was diagnosed with hepatitis C brought on by drug abuse. On top of the Kidman rumours, there was the prospect of Rachel Weisz appearing in the proposed *Marlowe*, then the wife-swapping exposé was in the wings...

In the poet Marlowe's words was Rudy 'born of parents base of stock...'?

E-drop in Colombia House

The entire *Cold Mountain* team moved back to Romania in December 2002, to shoot some remaining sequences but, just a week into the shoot, Jude had to take an urgent call: his two-year-old daughter, Iris, had swallowed an ecstasy tablet at a kids' party in Soho House.

The party was being thrown by Pearl Lowe – girlfriend of Danny Goffey, the drummer from Supergrass – to celebrate the fifth birthday of their son Alfie. She and Sadie had become friends again since the wife-swapping some 18 months earlier. Pearl and Sadie have been friends since they were 16-year-old ravers, fucking every dealer and popping every pill in sight. She asked Sadie who was there with Iris. Although the £400-a-year club was the joint for the partying set, on Saturdays owner Nick Jones opened its doors to the members' kids.

The club lays it on: fresh lemonade, fairy cakes, trifles, sausages on sticks, party hats and tea and coffee for parents on the waggon. There is a superb cinema complex at the top of the three-storey club and part of the show is a children's film. On this particular Saturday, after the food, all the kids went up leaving most of the adults and also Iris who was only two. She was sitting on Sadie's lap on one of the squashy leather sofas.

Pearl noticed Iris '…rummaging around on the sofa, as children do, and then put her hand into her mouth'. In fact, she had been rummaging around in a handbag that was also on the sofa. Pearl continued with the story, 'Both Sadie and I were on to it straight away. Sadie grabbed her hand and pulled out this pill from inside her mouth. It had been in her mouth for a split second. I looked at it and I was horrified because I thought it looked like an

ecstasy pill.'

They were both looked at it quietly. Sadie was very calm. While Iris cried at losing her sweet, Luke another adult who was present and knows his drugs took it from Sadie, tasted it, then immediately confirmed it was an E. Sadie already knew that.

She Iris up in her arms and said, 'I'll have to take her to hospital… just in case.' Pearl asked Zoeth, another friend at the party and who had come by car, to drive Sadie and Iris to University College Hospital just over a mile away in Euston. Sadie was frightened but not in a panic. She knew that the effects of the drug would take some thirty to forty minutes to kick in, so as long as she got Iris to hospital before then she would be okay. Her main concern was telling the Jude. She knew he'd hit the roof.

Iris now understood that something was wrong. 'I'm sorry Mummy, I'm sorry mummy,' she kept saying, but Sadie told her it wasn't her fault and they just needed to get her checked out by a doctor. Looking pale and drawn, Sadie did what she knew she had to but was dreading – ring Jude in Romania.

'What? WHAT? I can't fucking believe it...!' he said.

Sadie reassured him that the situation was under control. She said that she would ring him again once she'd seen doctor. Iris was examined immediately she reached the hospital. The medics listened ot the description of what had occurred, examined the tablet and decided that she didn't any emergency measures. She was prescribed a charcoal substance to absorb anything that may have been swallowed and was kept in overnight for

observation and tests to check whether the drug had done any harm. Other than some remote untoward side-effect she would be perfectly okay.

Sadie rang Jude again to tell him what had occurred but he refused to treat it as other than an emergency. He had already taken steps to book a flight. 'I'm coming back straight away... how did this happen?'

The problem for Sadie, Jude had a pretty good idea how it had happened. For some time there had been a lot of tension between them over Sadie spending so much time with the Moss Posse, the members of which exchanged drugs as casually smokers do cigarettes.

Jude is no prude over drugs but he resented the partying scene because wasted so much time and interfered with his work. He had told *Time Out*, the London listings magazine, back in 1999: 'I'm certainly no angel where drugs are concerned but it's got out control.' He added prophetically, 'Their presence in London at the moment is to a degree that's going to be ultimately destructive for all of us.'

Nick Jones rang Sadie as soon as he heard and told her he was very concerned – he had young children and, in two months, he had to re-apply for the club's licence. The official police report, filed the following day, said the tablet had been analysed and had been confirmed as ecstasy.

> The child was taken to University College Hospital and has since been released in good health. We conducted a tour of the venue and viewed the possible area where it is believed the child picked the tablet up from. This

could have been from the floor or hidden down one of the sofas. The manager stated that the night before, a party had taken place. [The report speculated about the origin of the tablet] It is believed that a customer had dropped it during the evening before the party.

Before Jude even had time to arrange a flight home, the headline had been sent electronically around the world via the *Associated Press* news wires: 'Police: Jude Law's toddler daughter swallowed Ecstasy pill at party.' Within minutes it was on news stations across the country, and the following morning, on the front pages of the papers.

Some reports suggested Iris had had her stomach pumped and had undergone a brain scan to check for neurological damage, but a press release issued on behalf of Jude and Sadie the following day by their publicist read: 'Following the unfortunate events on Saturday, I would like to clarify a few points. Iris Law received the appropriate medical attention required – however, this did not involve having her stomach pumped. Nor did she undergo brain scans as previously reported. She is at home with Sadie and her brother Rudy, whilst Jude is away looking after their eldest son Rafferty. This matter was dealt with by the police and is now in their hands. Jude and Sadie just feel like the luckiest parents alive, as no serious harm came to their daughter.'

The police investigation involving members of the Clubs and Vice Unit swung into action amid speculation that this could be the last straw for Soho House's licence. It had long been called Colombian House because of its reputation as the coke-snorting capital of clubland. The staff were worried, Nick Jones was terrified and the partying members were already putting out feelers for

membership of the nearby Groucho, which around this time had two in-house dealers. If only to insult to injury a few days before this incident a book called *White Powder, Green Light* had been published authored by some obscure hack who claimed he had been introduced to drugs at Soho House.

Millionaire Nick Jones, who is married to newscaster Kirsty Young knew that many in the press regarded the club as little more than a safe house for celebrities to take drugs. His view was that drugs are an integral part of the lifestyle of his clientele and it was impossible for him or his staff to police that. Certainly, no one could remember anyone's membership being withdrawn because of drug-taking even though numerous journalists have documented the evidence that pointed to it being rife.

News reports claimed that Jude had sworn to boycott Soho House and had spoken to his lawyers – 'Jude plans to sue Soho House'. But this was later denied. And then came the backlash. In some sections of the media, criticism was being levelled at Sadie for choosing to take her young daughter to a nightclub or 'trendy den' as it was called, in the first place. Reporters also recalled when Sadie was picked in Berlin because she out of it and put in 'drying out cell' for her own safety. She was released without charge. They also recalled that many of her friends in the Primrose Hill set, like Liam Gallagher, Meg Mathews and Kate Moss, had been in various drug clinics. Some of the reports more or less said that she was a druggie herself.

'Jude and I aren't some rock'n'roll couple,' she retorted. 'I still can't believe all this happened. I'm not a bad mum; nobody was taking drugs that afternoon. If I had seen

anyone taking ecstasy or anything else I would have been out of the door immediately.' She told the *Evening Standard* it was all 'mummies and grannies, and cups of tea' and that she doubted it had come from one of the guests. 'There are drugs everywhere in London, and it's pointless trying to speculate who had left it. That was certainly not my priority that afternoon.'

Nick Jones, meanwhile, kept his head down. A spokesman for the club stated: 'Nick will not talk about members, former members or incidents at the club because it is a private member's club and that's the policy.'

However, behind the scenes they were briefing like mad. The main point was that everyone knew, even though there was no hard evidence, that Iris fished it out of Sadie's handbag. The subsidiary points were that the club was thoroughly cleaned that morning and that no pill, whether on the floor or behind the sofa cushions, would have remained undetected; anyone who know anything about druggies is whether rich or poor if they drop a pill come hell or high water they find it.

Pearl Lowe is vehement that it wasn't Sadie's. A week after it happened she was backstage after a Libertines concert, which featured Pete Doherty, and a girlie commented that everyone knew the kid had fished out the tab from Sadie's handbag. According to Pearl, she went 'ballistic' but what she was doing backstage at a Pete Doherty concert she didn't say. But Pete was certainly hoovering up plenty.

Not long after the incident, Westminster City Council enforced new regulations as part of the conditions attached to renewing the club's licence. It required the

renovation of all toilets which got rid of all flat surfaces, making snorting cocaine more difficult. In addition it required a 'one person at a time' rule to be enforced in toilet cubicles, and demanded that the they be visited by a valet every 15 minutes. Members still called the place Colombia House.

Jude stayed in London for two days. He was cold and belligerent towards Sadie, whom he blamed for the incident. There slanging matches about her own use of drugs and his use of Nicole Kidman. It had been established that she was Jude's close friend and 'a shoulder to cry on', which became Sadie's sarcastic term for what she believed was their affair. Anyway, he had to fly back to Romania to finish the shoot but this was the point when their marriage was effectively over.

Needles to say, Minghella was impressed with Jude's energy and commitment to the film: 'If you had been with me on the last day of the shoot, you would have seen the same person you saw on the first day, with the same willingness to try.'

Nevertheless, he picked up on Jude's reluctance to 'carry' or 'open' a film. 'It's true of all wonderful actors that they somehow are in a complex relationship with stardom,' he reflected. 'Particularly British actors; they mistrust it, and they want the regard of their peers.'

Jude trusts Minghella. He admitted after the film that the director had '…said it was time that I stepped up and took the full responsibility of a film this size on my shoulders.' Then, he added in a rare moment of personal insight, 'The film is about self-discovery and about a man who is very introverted and very moral, and I think that

rubbed off on me. It was the first time I felt that I was playing someone I wanted to learn from and emulate in some way in my own life.' He did not elaborate.

Shortly after returning to the UK, Jude's publicist announced he would be working on a new science fiction film – provisionally titled *The World of Tomorrow* – alongside Gwyneth Paltrow. It was flagged as a big-budget 'retro sci-fi' flick.

Meanwhile, over Christmas and New Year, the entire family jetted off to Thailand to escape the traditional English Christmas, which Sadie, in particular, couldn't stand. She was still suffering from post-natal depression, which was aggravated by her fears that despite the denials Jude's roving eye had been more than looking at Kidman. He in turn was still simmering over the ecstasy tablet incident.

One slice of his workload that he was now eager to relinquish was his involvement with Natural Nylon: on 8 January 2003, it was finally revealed that he and Sadie would be pulling out of the production company they had set up with their friends seven years before.

Co-founders Ewan McGregor and Damon Bryant had left the year before but with Jude gone, too, the company's future looked bleak. It had been beset by funding problems, the actors who had given it their all in the beginning had increasingly busy schedules and less time to devote to its affairs, and whatever had been brought to fruition had not been commercially successful.

Kevin Loader, a producer attached to Nylon, put out a press release that Jude and Sadie would continue to have

links with the company and that there exciting projects in the pipeline, but the he would say that. The company was dead. All the main players had gone back to doing what they do best – acting.

On the other hand, at this time, Sadie's company was going from strength-to-strength. FrostFrench announced it was to produce a line called Floozie for the Debenhams department store chain. The store's chief executive Belinda Earl said she was delighted to be collaborating with Sadie and Jemima. 'They are a high-profile partnership with great ideas,' she told the press.

Soon afterwards Sadie was admitted to London's Cromwell Hospital amid newspaper reports of a 'suicide scare'. Jude immediately released a statement through his then publicist Simon Halls saying Sadie was 'feeling very blue' after the premature birth of their son. 'This depression can be a serious thing and it has left Sadie feeling very sad and run down and she is just trying to get a handle on it.' He added, 'Her treatment does not involve taking drugs – just seeing doctors, talking and recuperating. Sadie will be in the clinic for a couple of days more and it is doing her the power of good.'

Her treatment does not involve taking drugs! Poor Jude, he never gets the real life script right. The reason anyone goes into hospital for depression is to received drug treatment – unless, of course, the 'depression' is a synonym for taking an overdose.

Simon Halls said rumours of a suicide attempt were untrue. On top of having to deal with postnatal depression, Sadie was incredibly busy with work and had four kids to look after. In addition, she and Jude had

recently bought a new house in Primrose Hill which needed refurbishing – and as her husband had been abroad filming, it was up to her to co-ordinate the work. She badly needed a break. All this sounded like a PR man protesting too much. The fact was Jude was forcing a split and Sadie made a half-hearted attempt to slash her wrists in a classic cry for attention.

Some tame journalists were briefed on the cause of all the stress: 'Sadie is a mum of four trying to cope with a thriving fashion business and all the demands of multiple motherhood, while her partner is invariably on a film set half a world away. Something's got to give and in this case it's Sadie.'

She was quoted on her depression: 'It was horrible. I had mood swings and was insecure. I just couldn't cope… I got upset but didn't cut myself. I was really lucky to have people I could trust, who were supportive.'

Sadie's spokesperson Meena Khera admitted there were problems with her client's marriage but attributed it mainly to the time she and Jude had spent apart. 'They do both want to try to make it work and things have been a lot healthier since they had a holiday in Thailand over Christmas and the New Year. Working on a film together is just what they need as they will be able to spend time with each other.'

Jude's regular absences due to filming, Sadie's corrosive jealousy and her inability to contain it, and the events involving Iris at Soho House, had driven a wedge through their relationship. In short, their marriage was in its death throes.

In February, Sadie's father David Vaughan, who had been in and out of hospital in Manchester with hepatitis C, unveiled a series of disturbing paintings with titles such as 'Sadie in a Mental Prison' and 'The Crucifixion of Sadie', which he said depicted the torment his daughter was going through. Vaughan's work had taken a dark turn of late, depicting death, poverty, torture and war. His daughter's unhappiness compounded his mood.

Sadie checked out of the Cromwell Hospital at the beginning of February, claiming she felt much better after her treatment and said of the rumours: 'There is absolutely no third party in our marriage. To suggest otherwise is malicious, hurtful and libellous.'

Nonetheless, they separated. Sadie moved into a new house with the kids, which was half a mile away from their old one where Jude stayed. There were a number of reports in the press of 'divorce lawyers' being consulted, 'marriage over' and 'crisis talks'. *The Sun* claimed that, despite the public show of unity, behind the scenes divorce lawyers were jockeying over the spoils.

Newspapers were suddenly full of 'marriage over' and 'crisis talks' stories. Jude's awkward relationship with the press turned venomous as he saw his private life turned into a soap opera. He expressed his fury at the 'malicious, mean-spirited and untrue stories' that had linked his friendship with Kidman to Sadie's depression. He denied that they were divorcing and appealed for privacy so they 'put their lives in order'. He added despairingly, 'This obsession with tat and gossip… it's like a cancer that's taken over.'

Around this time, Kidman's claims against the *Daily Mail*

and *The Sun* were settled. She was awarded 'substantial' damages from *The Mail* plus a public apology. Her lawyer, Gideon Benaim, told the Court: 'The publication of this article has caused grave damage to the claimant's personal and professional reputation and she has suffered considerable embarrassment and distress.'

Lawyers for *The Sun* also admitted that paper's reports had been false and agreed to pay her damages and legal costs. Kidman announced she would be donating the money to a charity that helped abandoned children in Romania. So legally the one leading lady Jude definitely had not had an affair with was Kidman.

The 'estranged lovers' couldn't keep their strife private. In mid-March, the *Daily Mirror* reported that a meeting in Marylebone's Surprise Café ended in them screaming and shouting at each other. Jude slammed his hand down on the table, yelling, 'I can't deal with this any more I've had enough.' He got up to leave, which started Sadie crying. She begged him to stay. It was straight out of *Eastenders*, and all very, very undignified.

At the end of March, Sadie's dad decided to take matters into his own hands. He discharged himself from the Manchester Royal Infirmary and turned up at her house threatening to shoot Jude. Vaughan later explained: 'I've been on a lot of medication and feeling stressed. I probably did make a few threats but I didn't mean any of it.' There were more reports of 'vicious rows' in public and calls to the police to deal with 'domestic disputes'.

While Jude's personal life was taking a turn for the worst, *Cold Mountain* was in post-production; at a small studio near his house in Primrose Hill, a man called Walter Murch was busy editing the movie for release at the end of the year. Miramax and co-chairman Harvey Weinstein was hopeful that it would be an Oscar contender.

By May, Sadie was insisting her split with Jude was only temporary. They needed to talk, she said, and it hadn't been easy under the constant glare of the media. 'We're just going through what lots of couples go through,' she claimed. Three months later she issued divorce proceedings, citing Jude's 'unreasonable behaviour' as grounds. 'Unreasonable behaviour' can encompass a number of grounds but more often than not it refers to adultery.

Her statement read: 'I have come very reluctantly to the decision that my marriage to Jude is over. We have agreed that a divorce is the only way forward but we have equally agreed that we will do everything in our power to make certain this is as painless a process as possible for the benefit of the children. They are our number one priority and have always been so and will remain so.'

Sadie didn't hang about: soon afterwards she began dating a 22-year-old flamenco guitarist, Jackson Scott, whom she met through Kate Moss. Inevitably he was tagged her 'toyboy' and the press covered their liaison as avidly as they had the break-up of her marriage. Sadie flaunted the new love like he was a reproof to Jude.

Jude just kept his head down and, as always, buried himself in his work. To elude the paps, however, he started travelling under the pseudonym Mr Blanchflower.

Danny Blanchflower had been the captain of Spurs in the 1960s when Tottenham Hotspur had been in their pomp. He also booked into a specialist clinic in Los Angeles for the removal of his tattooed reminder to stay faithful. 'Sexy Sadie' had finally played out its irony.

The work was piling up ahead of him: the *World of Tomorrow*, *The Aviator*, a remake of the Michael Caine vehicle *Alfie*, a movie version of Patrick Marber's stage play *Closer*, a quirky American film *I Heart Huckabees*, and a voiceover for a new Jim Carrey film Lemony Snicket's *A Series of Unfortunate Events*.

'The work that came up was really exciting,' Jude noted, 'and I didn't want to turn any of it down. It was logistically possible and do-able that I could work on all of them…and I suppose, yes, because of certain things going on in my private life – it was a way of channelling

energy into a positive thing. The idea of really pushing the limit – of digging up fumes to keep going and still being fresh – was really interesting. I want to be greedy. I want to be greedy for a little while.'

Although the films would take a year and a half to make, they were all be released within weeks of each other. *I Heart Huckabees* was filmed for less than $20 million but it gave Jude a chance to work with Dustin Hoffman and Isabelle Huppert as well as writer/director David O. Russell. The latter recalled why he cast Jude:

> The character goes through a complete meltdown crisis, and Jude was kind of going through one of those in his life. He really related to it… I thought, this is a bit of a jackpot. He is really going to be able to take all this energy and use it in the movie.

Russell pushed Jude in *Huckabees*. 'He pushed me in a kind of rough way,' Jude would later say. 'Opening up enough, feeling free enough, brave enough to dive in and bare your heart, your soul…for me, playing a character who had to be believable but also utterly fake... The kind of person who is so convinced they are genuine, they lose sight of the fact that it's all based on falsehoods.'

In this 'existential black comedy', Jude's character tells the same pathetic anecdote time and time again before realising how repulsive he sounds. As consequence, when he tells it one more time during an important board meeting, he is physically sick into his hands. The scene took three takes. Russell remembers the shoot, 'Jude laughed hysterically and said "you will never use that." He said he'd give me $100 if I used it, so he owes me the money now.'

Hoffman also took time out to talk to Jude. He'd listened

with Mark Wahlberg, Lily Tomlin and Dustin Hoffman in comedy *I Heart Huckabees*

to him witter on about the press and heard him agonising over his problems. The usual angst-beating. Hoffman's a wise head. In his laconic way, he just told Jude:

> Look, you're in a fantastic position and in a wonderful profession. Enjoy it. Stop beating yourself up. It's a good life. And it's the only one.
>
> *This isn't a dress-rehearsal.*

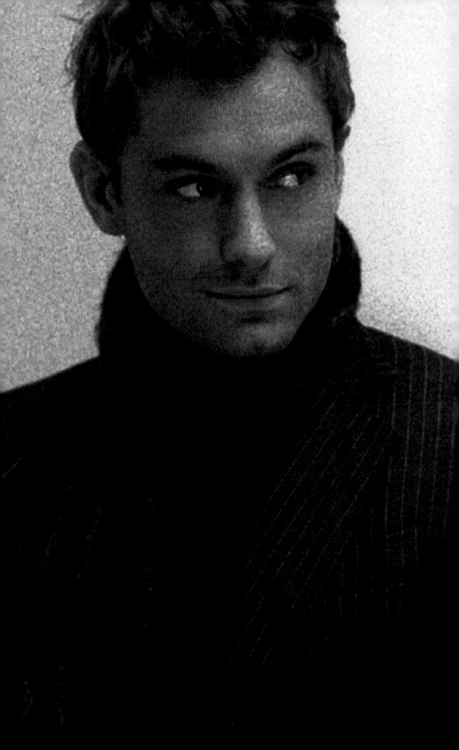

chapter eight

Whatsit all abou'?

Look at this man! He is biologically incapable of being faithful to one women... Would you if you looked like that and were a successful, rich movie star? Fess up, be honest here.

FRYLOCK [BLOGGER]

'I didn't want to do *Alfie*,' Jude recalled. 'My initial reaction was: A remake? Don't like remakes. Of a classic?... No way.'

Alfie began life as a radio play called Alfie Elkins and his Little Life, was turned into a stage play in the West End in 1963 and, three years later, was made into a film starring Michael Caine. forty years later, it still sells on DVD and is regularly re-shown on TV. Another very good reason for Jude's initial reaction was that Caine's Alfie was definitive. Yet, even as he turned it down, niggling at the back of his mind was the idea that really he ought to rise to the challenge.

So Director Charles Shyer didn't find it that difficult to persuade Jude to accept the part; he told him to think about it in the same way as he would think about revisiting *Hamlet* – 'as a classic text'.

Of course, *Alfie* wasn't text, he was Caine.

Jude knew that the critics would look at it as the new generation going to head to head with the old. From the moment he accepted the role, he and Shyler were keen to defuse that by emphasising that the re-make would be about bringing the story up to date for an audience that viewed womanising a lot differently than it had forty

years previously. There's little doubt, however, that Jude intended his version of *Alfie* to be at least as successful as Caine's. He just wasn't daft enough to say it.

Jude pointed out that the goalposts of male and female relationships had changed: 'I think as a culture, the West has found itself in a sort of strange – not battle of the genders – battle in one's own gender. It's not just the guy who takes advantage. I also know a lot of 'Alfie' women who think power is about wielding their sexuality.'

Jude figured there was a little bit of Alfie in everyone; that men and women everywhere would be able to relate to this person: 'We can all identify with having been either the dumped or the dumper or the cheated or the cheater at some point in our lives. I had my Alfie days. My late teens, those years where you're legally allowed into bars and clubs and the world is offering itself to you. But I was someone who always looked for commitment: that's why I got married and had children.'

Well, yes he did but he went straight from womanising to being married, which means fidelity and commitment would not come easy. The point that Jude does not understand is that New Age Metrosexual man is not keeping his sexist tendencies in check. He actually doesn't feel the Alfie urges because they are not present in his sensibilities. Jude has never extinguished the womaniser from his character and every now and again it breaks out despite his resolve to keep it contained. Still, it probably makes him a better actor to live a bit of a lie in his personal life.

Jude went on to deal with the moral of the film: 'Alfie tries to seduce you – the audience – and then, eventually, he

can't help but show the cracks.' He was asked if *Alfie* was as relevant today as he was back in 1966, he replied, 'Can and do people still behave like that? I think the answer to that is yes.'

Another challenge that *Alfie* represented to Jude was that this was the first film he would 'carry' in that he was to be in frame for most of it, so its success or failure would be on his shoulders.' Testimonials that he would be up to it came thick and fast, including one from Caine: 'I think it's great that Jude is playing Alfie. He is a friend, and I'm a great admirer of his. I think he's a wonderful actor.'

The besotted Minghella emerged from the closet to put in his two-penneth. He, naturally, had no doubts Jude would carry it off. He described him as '…one of the most handsome men on the planet. He is a character actor struggling to get out of a beautiful body.' Vassili? Maguire?

Shyer was even more out of whack in his eagerness to suck up to Jude's New-Age man image: 'Jude is by nature a kind of shy person, and some of the things that Alfie does are pretty out there. It's so not Jude. And he really had to step up and do things he would never have normally done. It's complete and utter commitment.' Shy! What about *Indiscretions*? Jude is an actor and a very good one, too, who can do sex scenes and who can do naked.

Nonetheless, Jude decided that he should have a body double for the more explicit sex scenes and Shyer agreed. Consequently, when Alfie has sex with Sienna Miller and Mirasa Tomei, the male body is not Jude's but stand-in Gavin Dixon's.

It was Dixon's first break in movies. Afterwards he commented, 'I still can't believe it has happened. I had a romp with two of the most beautiful women in the world, and I got paid for it.'

At least Dixon was being honest. The mindless posturing of Law and Shyer on this issue is transparently dishonest. The body double wheeze certainly didn't protect the actresses physically or emotionally as the sex scenes were not made less explicit by substituting Dixon for Jude. The effect of it was actually to demean the two actresses both professionally and socially. Jude was pulling rank on them over an issue that everyone in the industry knows is far more contentious for actresses than for actors.

The justification for this was also quite false. It was not done to protect Jude's newly discovered sensitivity to participating in a sex scene, it was done to give his image some cover from being tarred by the *Alfie* brush. Thus, any accusations that he clearly enjoyed his romps in *Alfie*, he could upstage by saying that in the more explicit scenes a body double was used. It had the New-Age ring of confidence: pure protection against any accusation that Jude had suffered an outbreak of his leopard spots.

The same kind of doublethink was at work when someone pointed out that Alfie didn't practise safe sex. Jude bit venomously, 'Let's be honest, shit happens. Does everyone out there who sleeps with seven different women wear a condom? This is the reality of an arsehole like Alfie... in the heat of the moment, tanked up on tequila, people don't and that's a reality.' Erica Coburn just cracked up when her attention was drawn to this remark.

Ostensibly, using a body double looked a neat tactic. The trouble is it didn't work and had the the opposite effect to what was intended. It didn't pull the wool over people's eyes, it opened them to a man who is insecure about keeping his womanising tendencies in check. Jude knows his break out occasionally and betray both what he wants to be himself and the image he presents to the public.

It was probably this kind of artistic dishonesty that infected the making of Alfie because it should have been a very good film. In fact, it was a flop critically and at the box office. But 'tis an ill wind…through *Alfie* Jude met and fell in love with Sienna Miller. Ohhh… he also got £8 million for the part.

Vanity Fair described Sienna as having 'the knowing sex appeal of Julie Christie and the blatant beauty of Brigitte Bardot'. She was born in New York in 1981 – nine years after Jude – and despite being sent to boarding school in Berkshire and living in London for a while, she eventually returned to train at the NY Lee Strasberg Institute – the London one was run by her mother – before before finding work, primarily in the theatre. When she was 16, a Select model agency scout recruited her and her biggest payday was as Miss September in the Pirelli calendar. She posed topless on a horse. And she was sitting not riding.

She first met Jude during a screen test at Shyer's home where the three of them sat in his living room, drank some wine and went over the script.

Jude said, 'It blew me away when I first saw her on camera. I just hadn't seen anything like it. I think she's extraordinary.'

While he was in Manchester during a break in the filming of *Alfie*, Jude had talks with England captain David Beckham about the possibility of his production company Riff Raff making a series of short films. An 'insider' told one newspaper: 'David wanted to do some-thing with Victoria, and Jude suggested a series of short films on a variety of different themes. He mentioned that his production company could handle the movies in a joint deal.' His dreams about production were clearly not tied to Sadie and his Nylon mates.

But within two weeks the deal was off. Still shell-shocked by the sheer amount of tabloid coverage given to the break-up of his marriage, Jude became worried about the level of press attention that teaming up with the Beckhams would bring. He could feel the rats crawling all over him again. So that idea was shelved, but at some stage in his career Jude will definitely move into production. As news broke of Jude and Sienna's fledgling relation-ship, the media became greedy for any story. The World Entertainment Network – one of many 'wire' services that feed the world's newspapers, magazines and

TV channels with showbiz titbits – claimed that Jude had swept his co-star off her feet '...with his dancing skills. He's such a great dancer already. He hasn't stepped on my toes once... I'm having so much fun at the moment.'

A day later, however, the *Evening Standard* carried a full-length interview with Sienna in some early pre-publicity for Alfie. Despite 'being trailed by packs of paparazzi' both were tight-lipped. Sienna simply said: 'It's very flattering for me as an actress at 21 to be doing a film with someone like him, and he's great... You do fall a little bit in love with everyone you're working with on some artistic level. I'm convinced of it...but I don't want this interview to be about Jude and my private life. I'm really not happy talking about our relationship.'

On October 29, Jude and Sadie's divorce papers finally came through. Neither was present in court but Sadie's affidavit declared: 'The respondent's unreasonable behaviour increased the effects of postnatal depression, leading me to have to take treatment three times.' To ensure that the press carried her statement it was faxed to an English tabloid even before Jude received a copy.

Despite saying he wouldn't, Jude found himself talking to the press. When one reporter put to him the old cliché that the three hardest things in life are death, moving and divorce, he replied: 'Well, I've done all three, and I have to tell you divorce is the hardest. And that's all I'm going to say.' But he couldn't resist saying more. He described being on the inside of the tabloid frenzy as 'like being locked in a car when the handbrake suddenly releases and you can't stop the car rolling into an inevitable crash'; another time, he said compared the paps as 'descending on the family like a horde of starving rats'.

In for a penny in for a pound – he also decided to rebut the charges of domestic violence: 'There were two instances where the police were called for whatever reason to my old house and they sold the story, telling lies. The police were responding to phone calls that happened, but they were then coming out and creating an atmosphere, a drama, when actually nothing had happened; there were no charges pressed. But that's the High Court and then the police selling stories, so how are you going to live in a country and feel safe?'

He was gabbling.

He just couldn't, even though he wanted to, follow the Day Day-Lewis script, which is give the press absolutely nothing. When you have the kind of previous that Jude has, really the only other alternative to giving them nothing is to give them everything. To give them a little bit, they always take as an invitation to badger you for the rest. It's their job for christsake.

The divorce negotiations were predictably messy and expensive as they worked off their rage at each other through their lawyers. One insider said they both 'lawyer-happy…the legal thing with those two is total lunacy'. Whenever they met, even in public and with the children in tow, all dignity went out the window as they went at each other hammer and tongs. One friend said of it, 'They spend so much time sniping at each other that it leaves them both exhausted.'

Eventually, the astronomical 'disbursements' bill brought them to their senses and they hammered out a financial settlement in which, given her position in family law, Sadie was more graciousness than him. She had come to call hm

'Moody Jewdey' as a lot of his moans involved money. She got their Primrose Hill home and £4 million, plus a monthly income of £20,000 until Iris is 16 years old. The battle over residence was resolved by agreeing that the children would have the choice to live with either parent. As they decided to live near each other in Primrose Hill, this would mean the kids could see either parent whenever they wanted. They both signed 'gagging orders' that they did not disclose details of their marriage or divorce settlement to any outside party. In an interview soon after with breakfast television programme GMTV, Jude stated: 'I feel stronger emotionally and happier in myself, if not a little battered and bruised…it was as hard for us to tell our children as it has been for any couple. Just how do you explain that to a child? All you do is hope something positive comes from it in the end.'

Sadie told one magazine that they had grown apart because Jude always put his career first. She told another reporter: 'It's no secret I've had a terrible year. In fact it's the worst of my life. My marriage has crumbled and the spotlight has been on me. It's been very hard. I have been depressed, but I finally feel that I'm coming through it. I lost a lot of weight and wasn't looking my best so I was being scrutinised by everybody and it's never nice to have people say bad things about you.'

Sadly, in the end, they did what they had always said they wouldn't – parade their private lives in public. They both proved incapable of rising above their differences and taking consolation for their problems from their privileged and charmed lives.

Sienna Miller is as different from Sadie in personality as she is in looks. For Jude this was a complete about-turn.

With Sadie he had 'a 50-50 relationship…we understand each other and the ridiculousness of our careers.' Suddenly, with Sienna, he was the dominant, supportive, traditional man: all very non-PC, but surprisingly satisfying…at least while it was novel.

How they were can be gleaned from one fragrant hackette who interviewed them after Jude had done a charity gig for an Oxfordshire hospice in May 2004.

> Jude auctioned his shirt, removing it by coquettishly walking on stage and doing a partial strip. There were shouts from some slightly inebriated female students to 'get 'em off', but he refrained from the full Monty. When the auction ended, the satellites were left in orbit while the stars rocketed off to Raymand Blanc's Le Petit Blanc, where they gorged on champagne and caviare finger-food that probably cost more than the auction raised. Still, what are charities gigs for if not to give celebs a fee in kind and raise the price of their 'caring' portpholio?
>
> Some students, who had gatecrashed the party, had buttonholed Jude and were talking earnestly about Marlowe and Shakespeare. It was all very highbrow replete with references to literary theory (whatever that is) but he seemed to be holding his own – after all he has played Dr Faustus. Sienna was in the background, listening as if she understood every word, which patently she didn't.
>
> She is no intellectual. She comes from an upper-middle class American family that educated her at an all-girls boarding school in Surrey.

We used to do stupid, fun girly things like pull tights over our faces and streak through the lacrosse pitch. And once I snogged the gardener.

Wow. In fact, she is a Sloane clone. Blonde, skinny, attractive, bright, intelligent but not over-endowed with grey matter (she didn't got to university but writes her own poetry). She is also quite plain in the flesh and her current razzle-dazzle rests purely on her relationship with Jude and that peculiar quality of being photogenic. The camera makes her much prettier than she is. As an actress, she has utterly no presence and not much talent. But she is nice, and she is very, very proper.

She was wearing a black chiffon Mathew Willaimson dress with the printed peacock feathers and black cowboy boots. However, she rarely took her eyes off Jude. She simpers around him and when she is near constantly touches and fawns over him. It is slightly infantile the way she squeezes his hand and tugs at his clothes, but she is besotted as Mighella and a lot more desirable. He absorbs her attentiveness like applause from the audience – appreciatively but also his due. They both chain-smoked throughout the evening but their eye contact, as they lit up and drew on their cigarettes, suggested that she fancies him more than he does her.

Jude's new relationship would be constantly under the flashlight. There was no escape from the press and he was, in turn, bewildered and apoplectic at all the attention. Even a walk to the park had to be planned in consultation

with his security guards. During one of his exasperated moments, he ranted: 'I realise there's always the argument that I asked for it but, even if I did, my kids fucking didn't. And hearing my daughter say the word 'paparazzi' is like hearing a three-year-old saying the word 'c**t'.' On the other hand it's good to acquaint your children with foreign languages early.

Jude found that the only way he and Sienna could evade the prying lenses of the paps was to go abroad. They did some filming in New York, then jetted off to Paris. When they returned Sienna said, 'I can't remember being happier than I am now.' Meanwhile, Sadie's father, David Vaughan, died while in hospital waiting for a liver transplant. He kept raging at the inequities of society until the end. His painting survive him and sell for a lot more than they did when he was alive. Sadie effected some kind of reconciliation before his death. He was 53.

Christmas 2003: Sadie, Jude and the children all spent the day together. She said they still cared for each other: 'How could we not? We did spend 10 years together. I think the pressure of the fourth child, the house, the work, not being together – it just added up to a big kind of explosion…but he cares a lot for me and I care a lot for him.'

Cold Mountain premiered in Leicester Square on December 15th. Nicole Kidman and Jude arrived together to be greeted by scores of photographers and thousands of screaming fans as they stepped out of their car and onto the red carpet. Ray Winstone trailed behind them. In his inimitable style Ray told reporters: 'Romania's a shit-hole. I'd avoid that place like the Isle of Man.'

The reviews were excellent and Jude was, as usual, singled

out for praise. *Time Out* called it the year's most rapturous love story and claimed the acting was 'full of satisfactions and surprises'. Jude, it went on, 'has movie-star musk and the craft to fill his peasant garb with a heroic sensitivity.'

David Thomson of *The Independent* wasn't convinced but explained it in such a way that no one could understand what he meant:

> Law's ability to seize attention is not quite natural. It's something he can do when maybe he's still shy of simply being himself. And the largest burden of carrying any film is being yourself, and trusting that the audience is so fond of you, or so understanding, that they'll accept the placement. [Note: If you didn't understand that, please don't waste your time reading it again because you're in good company – no one else has.]

Jude received a Golden Globe nomination for Best Actor – one of eight prizes for which *Cold Mountain* was in the running. One critic proclaimed Jude's world domination to be 'only in its infancy'. But again he was to miss out on the Oscars.

Jude next film, *Closer*, was shot in London and began in January. He was cast with Natalie Portman (with whom he'd worked on Cold Mountain), Clive Owen, and Julia Roberts. It was a sometimes humorous, sometimes shocking look at relationships through the chance meeting of four strangers and their casual betrayals.

Jude liked the honesty of the script; the fact that every emotion was on show – vulnerability, strength, anger, innocence. His part followed the pattern of his career in

that it was different from anything he had done before. He was still pushing pushing back the boundaries of his talent. After finishing *Closer* in March, he had a part in *Tulip Fever*, set in 17th century Amsterdam… His refusal to be typecast was steadfast. Jude had also committed himself to another project – but it didn't involve him acting. He had put his weight behind a £12.5 million drive to refurbish the Young Vic Theatre in Southwark – a space he adored. The theatre had enjoyed its most successful season ever in 2003, but it was falling down and in urgent need of repair.

Twenty photographers lined up on the pavement outside the theatre awaiting Jude's arrival for the press conference. He flew in from the Rome premiere of *Cold Mountain* and had 30 minutes before he had to leave to catch the Eurostar to Paris for the French premiere. But he did it. He also made a substantial contribution to the rebuilding fund

Of course, this was dwarfed by him simply associating himself with the project. His fame has a publicity clout that matches his fees, and he took a cool $10 million for *Cold Mountain.* But the press were still snapping at his heels – with a young, talented, nubile young Sienna Miller on his arm how could it be otherwise? No paparazzo or showbiz hack could ignore what a scoop on Jude and Sienna was worth.

But whatever it was worth it was a lot less than $10 million.

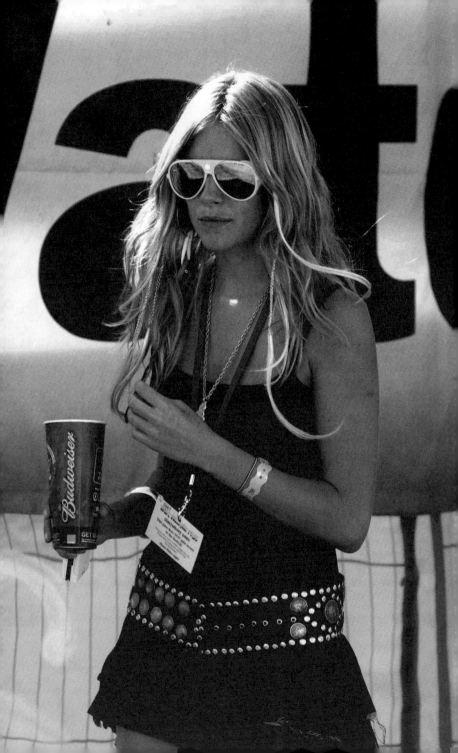

chapter nine

Burnt Sienna

Jude and Sienna's relationship was still in its infancy and the media speculation was just cranking up – but even at the beginning of 2004, there were endless reports of their spats and reconciliations.

According to the British press Jude had 'threatened to ditch Sienna if she didn't stop idolising him', was 'frustrated with her because she was disorganised', 'decided to move in with her', and 'wanted to marry her'. Jude gotten into the habit of squabbling with Sadie and it was ingrained now.

Jude feigned to ignore these stories, which were true even though the exact details more often than not had been puffed up on some hack's computer screen – and concentrated on *Closer*. Like *Alfie*, *Sky Captain*, *Lemony Snicket*, *The Aviator*, and *I Heart Huckabees*, it was due for release in late 2004.

Closer was an exploration of the mayhem that personal relationships can descend to. 'We've all heard those fatal words in a relationship where someone says, Just tell me. I promise I won't be mad. I just want the truth' was how director Mike Nichols described the premise of the film. In the actual movie, Julia Roberts is asked exactly that but, as Nichols put it, the character 'doesn't really doesn't want the answer because it's just a slide into what at one point he says to her, *Fuck off and die.*' Jude had been there, had the lawyer's bills to prove it and and didn't want to do a repeat except as an actor. As we know, however, The Fates had other ideas.

He was filming *Closer* after the most turbulent year of his life. It enabled him to '…purge all that on camera. I'd be lying if I said I didn't use a lot of what was going on.'

Closer became his own self-administered therapy, which director Nichols was only too happy to facilitate.

On February 15th – in the middle of the *Closer* shoot, Jude attended the BAFTA awards ceremony, hosted by Stephen Fry, his Wilde co-star and with whom he had a rather steamy sex scene back in 1997. Fry read out a spoof film review of *Cold Mountain*, 'allegedly' written by his mother, which alluded to the sex scenes between Fry and Jude in Wilde. Jude took the ribbing well, but not his failure to get his by now customary award.

Filming on *Closer* had finished by March. *Tulip Fever*, which Jude had signed up to make with Keira Knightley, was due to begin towards the end of April. But a reduction in the subsidies given to British films pulled the financial rug from underneath it.

This meant that Jude wasn't scheduled to work again until December. He decided to take a trip abroad with Sienna – she had always wanted to tour Italy. Meanwhile, Jude immersed himself in Philip Pullman's three sagas of magic and science, *His Dark Materials*, ate with Sienna at his favourite Mexican restaurant in Primrose Hill and played with Raffy, Rudy and Iris. Life was beginning to feel good again.

During the summer, they were careful about their public appearances: an occasional dinner at the Ivy, the 'celebrity' screening of Michael Moore's *Fahrenheit 9/11* and a trip to Wimbledon to see Tim Henman crash out of the singles to Mario Ancic.

In July Jude joined a host of celebrities including Bono and Minnie Driver in urging Tony Blair and Chancellor

Gordon Brown to increase aid to the Third World. A month later their signatures were attached to an open letter congratulating the government for increasing their funding but urging them to cancel Third World debt. A precursor to Live 8 in 2005, it was a sign to Blair that Britain's actors and musicians were prepared to use their celebrity status to highlight issues they considered important. Again, Jude was using his star status to draw attention to issues he thought should be in the public eye.

But what he thought was going to be a slack period gradually started to fill up with the usual workload. And with all the films he has just made coming up for release, he was drawn more and more into promotion. There was also the pre-production on *All the King's Men*, which he was due to start filming later in the year. It was a remake of Robert Rossen's 1949 biopic of a corrupt U.S. politician.

In addition, Jude had also signed up to star in *Dexterity* – based on the Douglas Bauer novel – which was being produced by Tom Sternberg with whom Jude had worked on *Ripley* back in 1998. As always, he put his work first but Sienna was content to put her tour of Italy on hold and accommodate to Jude's shrinking free time.

Towards the end of August Jude jetted off to Chicago to promote *Sky Captain* and the *World of Tomorrow*, which was to include an appearance on the Oprah Winfrey Show. A researcher had asked him whether it was true he used to breakdance as a teenager, insisting 'it probably won't come up in the interview because we'll run out of time'. But two questions in, Winfrey jumped up from her chair, asking him as the audience began clapping to breakdance. Jude didn't have much choice.

'It was a fucking nightmare,' he said afterwards, 'but there was no way out of it.' Still, he didn't burn his elbow and actually put up a respectable performance.

In September Sadie put on a fashion show to present FrostFrench's latest collection. Jude came along with Sienna, also present was Sadie's former husband Gary Kemp and her current beau, Jackson Scott, who by now was 23. Reporters at the show were spoilt for copy. One of them cheekily asked Sadie if Jackson was going to play the guitar. Behind her back there were jokes about her three exes comparing notes on how she'd been for them. 'What! She didn't do that for me' was the line that drew the most laughs.

There was also speculation about when Sienna and Jackson would realise that they were the right age for each other and would get it on together, leaving Sadie and Jude free to re-marry. The problem for Sadie Frost and Jude Law was that over the years the showbiz hacks had come to regard them as a bit of joke. And quite often, hacks being hacks, the jokes turned into stories.

Suddenly, Jude's face was everywhere. All the films he had shot over the past two years were concentinnaed on release. The Associated Press news wire, which is manned by deadbeats who couldn't even make it as a sub on a national, laboured through the night to come up with 'Jude the Far From Obscure'.

'I sort of wish they could have been slightly spread out,' Jude bewailed. 'Part of me doesn't want to think about it too much and is just hoping that they all get enjoyed and seen. I hope people recognise the variety rather than the onslaught... It's like two years of work in four months;

like waiting for a bus and then four come along at once.'
Huckabees director David O. Russell noted: 'Obviously as
a director, you always prefer your guys are mostly just in
your movie and not in any other movie at that time.' But
Sky Captain's Kerry Conran was cool: 'None of these are
going to be typical roles, and they're not going to be the
same role. He's been very much a chameleon of sorts.'

Arena magazine pointed one of the advantages for the
chameleon: 'Importantly for Jude this glut of work will
refocus attention on him as an actor after a year in which
he very publicly and uncomfortably found himself
besmirched in the grubby pages of the tabloids with
alarming frequency.'

After a brief holiday Sienna in Cabo San Lucas, Mexico,
he returned to London for the official London premiere
party for *Sky Captain* – held in Stella McCartney's Bruton
Street shop. Sadie turned up with her sister, Jude's father
Peter came along and Jonny Lee Miller was also there with
his mum. But after a spot of back-slapping it was time for
Sky Captain to face its critics. And not everyone was
impressed. With its 'cold shiny perfectionism' and the
project's 'monumentalism', *The Independent* wondered
gnomically 'Is this what cinema would have been like if
the Nazis had had CGI?'

Shortly after *Sky Captain*'s release the newspapers were
full of the next episode in Jude's own soap opera – he was
going to become engaged to Sienna. The morning of the
'announcement' Jude just shook his head in amazement
as as he read the headlines because he didn't know
anything about it. He began muttering to himself,
'Tomorrow it will "Shotgun Wedding – Sienna is
rumoured to be pregnant..." Fuckers.' Next his mobile

started to melt as friends and relatives rang up to congratulate him. The rats were crawling over his face...he felt like *1984*'s Winston Smith.

He rang his PR firm and ordered them to issue a press release denyng the story. He also spoke, not especially coherently, to a journalist: 'There's nothing more uncomfortable than being very happy and very much together and then receiving endless phone calls from the family and the press saying "well done" because you have to deny it.'

At the *Alfie* premiere in Leicester Square, held in aid of the Make-A-Wish Foundation, Sienna wore 60s style make-up and a little black dress to pose with Jude for the cameras. It was her first big film premiere and her excitement was obvious. Mick Jagger and Dave Stewart, who had scored the film, were also there. Sienna's excitement was not catching, though, as the critics were not impressed.

William Hall, Michael Caine's official biographer, was kinder than most: 'I think Jude did a remarkable job given the circumstances. He managed to convey a roguish charm with a wicked glint in his eye that was quite irresistible, and deserved a better response from the public. And quite honestly I don't think it will do his career any harm. You could say he got away with it... just.'

Alfie didn't get away with it at the box office. It took $23 million worldwide but cost $40 million. It also entered the Top 10 Worst Remakes of all time in a poll conducted by DVD rental firm Screenselect.co.uk. Coincidentally, the top 'flop' was a remake of another Michael Caine classic – *Get Carter* starring the muscularly-enhanced but

syntactically-challenged Sylvester Stallone. As he says, though: 'I need da muscles to carry all ma money to the bank.'

The biggest problem with *Alfie* was not Jude but the director, Richard Shyer (*The Parent Trap*, *Father of the Bride* and *Baby Boom*). Shyer is too family values and American apple pie for something like *Alfie*. Casting him as director was bad enough, but to let him co-author the script was asking for it. The script is falling over itself to give *Alfie* his feminist comeuppance, and it is not funny. Paramount got what they asked for with *Alfie*, a box office tanking.

Jude knew you could diss with the critics, but the box office judgement was infallible. Yet again he could and did take solace from the fact that, despite his 'carrying' Alfie, the reviews were relatively kind to performance. Shyer deservedly took it on the chin, Jude merely lost a split decision.

I Heart Huckabees fared much better critically. *The Guardian* called it a 'film that buzzes around your head like a great big autistic cartoon wasp…it's a stylised and unexpectedly warm portrait, witty, fractured, conceited and hyperactive – of how it feels to be an alienated twentysomething.' Similarly, the critics praised Martin Scorsese's *The Aviator*, in which Jude only had a small part but he played it well and memorably.

Closer premiered towards the end of 2004, when Jude was already in America filming *All the King's Men*. The first screening took place at Mann Village on November 22nd in Los Angeles, California with Julia Roberts away giving birth to twins. Natalie Portman took to the red carpet accompanied by Jude, Owen and Ewan McGregor.

Jude was wearing a brown velvet suit over an open-necked shirt as they faced the flashbulbs.

One critic wrote: 'There's a creepy fascination in the way these four characters stage their affairs while occupying impeccable lifestyles. They are all so very articulate, which is refreshing in a time when literate and evocative speech has been devalued in the movies.' With a budget of $27 million, it ended up taking $101 million worldwide. For Jude, but not the lacklustre Shyer, *Alfie* was history.

Back in London, UK *Vogue* had put Sienna on the cover of its Christmas edition and it wasn't only because she was stepping out with Jude Law. As far back as January she had been branded as the muse of designer Matthew Williamson, wearing at the Golden Globes a fabulous pink silk dress from his New York fashion week collection.

Then in June she had been pictured on the front page of the Daily Telegraph at the Glastonbury music festival wearing an ethnic 'hippy-chic' dress and beads, after which she single-handedly inspired a whole fashion season. Branded 'boho chic' by the style press, Sienna's look was soon replicated by high street fashion stores such as Next and Marks & Spencer; crochet tops, long flowing skirts and suede Ugg boots. *InStyle* magazine summed up the trend: 'Everyone has gone crazy for the Sienna Miller look.'

Vogue's teaser promised 'the low-down on life in the fast lane from the girl of the moment'. For the best part of a year hardly a day had gone by without a picture of Sienna appearing in a magazine or newspaper somewhere. She was the new It-girl.

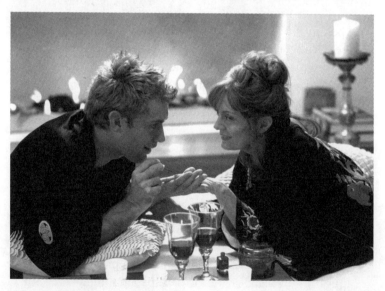

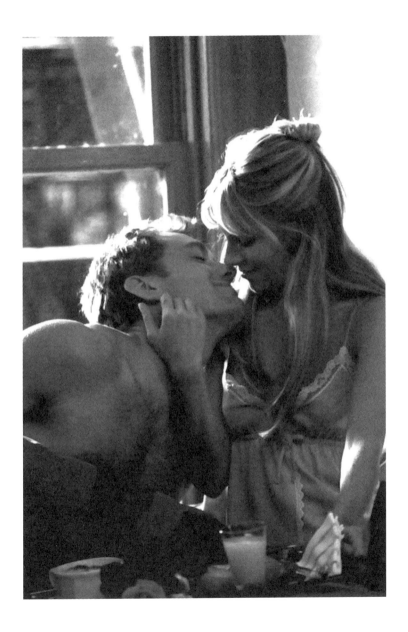

Jude and Sadie got together for a pre-Christmas meal with their kids at a cottage in the Cotswolds. Sadie then flew to Spain to join up with Jackson Scott, while Jude headed back down to London to be with Sienna. Later that day, he proposed with a £20,000 diamond engagement ring. She accepted both with alacrity.

Early in the New Year, at the British premiere of *Closer*, Sienna and Jude looked as radiant as her diamond ring. They had a happy-ever-after aura. The next day, Jude flew back to Lousinna to continue filming *All the King's Men*. He took their three children with him and to look after them the nanny whom Sadie had hired in August, Daisy Wright. She was a 26-year-old blonde with thunder thighs and a passing resemblance to Miss Piggy. Sadie knew that Jude could not be trusted not to bed his female leads but would his straying eye look below the stairs? Sadie being Sadie, though, and always bad with paperwork, didn't draw up a proper 'gagging order' in that it didn't cover Jude.

With the divorce settled, a new marriage looming and his career booming, Jude felt pretty good – even the rats were not in his face. Then, suddenly, they were all over him again. On January 30th, the News of World led with the wife-swapping story in Capri. It was bigger than the ecstasy splash. Both Sadie and Jude were besieged by the press, and badgered by their respective partners.

Sadie was furious with Pearl whom she blamed for leaking the story, while Jude blamed the whole Primrose Hill set. *The Sun* inimitably dubbed the place 'Promiscuity Hill'. Neither had a clue as to the real source of the story, which was Pete Doherty who gleaned it from Kate Moss. Both of them could only batten down the

hatches and deny, deny, deny. However, both found that their bedmates could not be kept at bay and did not believe their denials, although both Sienna and Jackson ran the deny, deny, deny line with the press.

When he was doorstepped at the Primrose Hill home where he lived with Sadie, Jackson Scott stonewalled: 'I don't know anything about it, I don't read those sort of papers. Sadie doesn't want to talk about it. It doesn't affect us.' But behind the door, Jackson did not like what had obviously happened nor, in particular, Sadie's refusal to come clean.

Sienna was shocked and 'freaked out' when she confronted Jude. Wife-swapping was just too sordid and lower-middle class for words. One friend pointed out the obvious: 'She is quite straight, has got lots of posh friends and is very much a public school girl. She's not got that attitude – which Sadie had – to go with it.' Sienna can be quite raunchy in the heat of the moment – one ex describes her as going down on his Old Etonian mate in the back of a cab while he had his hand inside her knickers – but the planned cattle market approach of wife-swapping is just not her scene.

A girlie friend of hers pointed out that 'Jude had never breathed a word about the things which he and Sadie would get up to and she (Sienna) just thought it was unreal. Jude of course said it was all Sadie's fault and blamed a lot of the partying and wildness on her, but Sienna found it utterly shocking that he could have got tarred with that kind of brush.'

Meanwhile, Sienna would go out to New Orleans where Jude was still filming but when she back in London she

began partying a lot with her Sloane friends. This meant she was often photographed out on the town. There was also her fashion work and modelling, which for Jude was all déjà vu of Sadie. He began to sulk and blame her for the way she revelling in the celebrity number, which he loathed.

After the Bafta awards in February, where she co- presented the award for Best Visual Effects with Christian Slater, she went on a 16-hour bender with Gael Garci Bernal and Rodrigo De la Serna, the Motorcycle Diaries stars, which took in Leonardo DiCaprio at the Boujis nightlcub. Despite Jude's pleas, she was out the following week at Matthew Williamson's fashion show at London's Kabaret Club, where she was flashing her knickers and spilling out of her dress.

At one point she *bent* the designer over the bar, pretending to have sex with him doggy-style, before jumping off a sofa and playing air guitar. She was merely letting her hair down in the wake of the wife-swapping publicity and her own elevation to celebrity, but Jude resented it. It became his excuse for seducing the nanny.

Neverthless at the Oscars ceremony in Los Angeles at the end of February, they were all lovey-dovey. Jude seemed to have put the allegations in the press to the back of his mind. He hadn't been nominated in any category, so with a stunning and adoring Sienna at his side he relaxed for any awards this year so it was a chance to relax and enjoy the show. Chris Rock was the compere.

The black – 'I'm from the ghett-*o*' – jokester hit the stage like a lungfull of crack. In his a velvet dinner jacket and a pair of diamond earrings, he was out to win his own

stand-up Oscar by sending up Hollywood's finest. He took no prisoners, and as he hit on someone the cameras swept across the Kodak Theatre, singling them out as they tried to smile at the jokes he made at their expense.

'You ever see a movie so bad that you question the actor's finances?' he asked. 'I saw that stupid *Boat Trip* the other day, and I immediately sent Cuba Gooding a cheque for $80.' He was only warming up.

'Now, you figure why don't some movies work? Well, it's 'cos the studios make them too damn fast... there are only four real stars – the rest are just popular people. Clint Eastwood is a star; Toby Maguire is just a boy in tights.'

Next it was Jude's turn. 'You want Tom Cruise and all you get is Jude Law? Who is Jude Law and why is he in every movie I have seen in the last four years? He's even in the movies he's not acting in.'

Jude took it OK but it was all too reminiscent of when Stephen Fry did him the year before. However, Sean Penn then made him cringe by sticking up for him when he announced the 'best actress nominees'. Penn said, 'What Jude and all other talented actors know is that for every great, talented actor, there are five actresses who are nothing short of magic.'

Backstage, Penn and Rock made their peace. 'I talked to Sean and we're cool,' Rock said. 'It's just a joke. Jude Law probably made a scillion dollars this year. I would never hit a person that's down.'

After the Oscars, Michael Caine offered Jude some advice through the press: 'Just make two films a year. Jude didn't

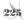

do all those films in one year, but no star has control as to when the pictures come out, especially when they're from several different studios. I'd tell Jude to slow down and ration this out a little bit.'

Shortly afterwards Jude changed talent agencies in California from Creative Artists to Endeavour, which led the showbiz media to speculate it was done out of anger following the Chris Rock jibes. From March 2005 Jude Law was being represented by Endeavour's Patrick Whitesell who also looks after Ben Affleck and Matt Damon.

Meanwhile, Jude revealed that he had accepted an offer from his old friend Anthony Minghella to appear in the director's new movie, *Breaking and Entering*, which was scheduled to begin shooting in April in London. For Minghella, it was the first time he had directed one of his own original screenplays. Ray Winstone was also in the cast with whom Jude always enjoyed working. Sienna was excited by the news as it meant they would be able to live together while he worked on the film.

Meanwhile Sienna was jetting in out of New Orleans to see Jude. In mid-March as she left, nanny Daisy Wright came in with four-year-old Iris to join Rafferty, 8, who was already there. Jude had been given an invitation to see Robert Plant in concert at the Beau Rivage casino resort in Biloxi, Mississippi, and he took her and Rafferty along. We already know how Jude got her tingling...and Sadie incandescent.

Some of the dialogue in Daisy, Daisy... is so cringingly bad it's classic. For example, Daisy recorded in her diary: 'We were chatting about us and the holiday and how sad

it was all coming to an end. He pulled me on to his lap and kissed my neck. We looked at each other and he said, "I think you are so beautiful and special. You are far too good for me." I didn't really know what to say, so I just said, "I probably am!"'

This is an object lesson actually in why people go to the films. It's so they don't have to listen to each other talk and, perhaps, when they have to to pick up some tips on how to do it better.

The affair went on for a MONTH! It ended when Sadie got on the case, but Sienna didn't know. Although it was obviously going to leak some way or another.

In the spring, while Jude was on the *Breaking and Entering* shoot in north London, Sienna began a three-month run in the theatre – the first time she had ever trodden the boards in England. She had landed a major part in David Lan's production of *As You Like It* at London's Wyndham theatre alongside actress Helen McRory. Lan had known Sienna, whom he cast as Celia, Rosalind's cousin, socially through Jude, whom he had directed in *'Tis Pity She's a Whore* and *Dr. Faustus* some years before.

Previews began on June 3rd ahead of the production's official opening at the end of the month and on the 22nd Jude made an appearance to support his fiancée.

However, on June 25th McRory fell ill in the second act of the matinee performance and doctors said she should rest for at least 24 hours. Sienna texted Lan to tell him she knew McRory's part by heart and that, if he agreed, she would step into her shoes at the last minute; her

understudy could take on the Celia role with little difficulty. Lan duly took up the offer.

The following day the cheesy British tabloids ran on the story. 'How Sienna the stand-in made herself the heroine', which was how the *Daily Mail* recounted Sienna receiving a standing ovation for her efforts.

It looked like he'd weathered the wife-swapping storm: Jude loved working with Minghella, he was able to spend time with Iris, Raffy, Rudy and Sienna, and Daisy was history. Meanwhile, Sienna was loving her first foray into British theatre. But The Fates had decided that it was all going a little too well.

On July 17th the *Sunday Mirror* led with the exclusive that Jude had been bedding Daisy Wright behind Sienna's back. Prior to the story breaking journalists contacted Jude for a reaction but he chose not to talk to them. More ominously, neither did he warn Sienna. He left her to find out like everyone else through the media. One of his pals explained, 'He went under the blanket. Who wouldn't if you were going to wake up to that, and your missus on the warpath.'

After the story hit the newstands, his publicist issued a statement on his behalf: 'I just want to say I am deeply ashamed and upset that I've hurt Sienna and the people most close to us... there is no defence for my actions which I sincerely regret.' Daisy had taped him. He couldn't couldn't deny, deny, deny and threaten to sue.

Sienna was shattered, humiliated and spitting bullets. But that wasn't the end of it. The following weekend the *Sunday Mirror* rubbed some more soap in her eyes:

'Cheating Jude Law tried to arrange a secret meeting with his nanny lover just last week,' it claimed, adding that he had told Wright that the thought of not seeing her again left a knot in his stomach.'

Sienna was eating the words she said at the premier of *Alfie* : when someone asked if Jude was like his his film character, she replied: 'He's as charmning but not such a misogynistic bastard.' However, Shyer's comment took the the sick bag prize:

'Jude is by nature a kind of shy person, and some of the things that Alfie does are pretty out there. It's so not Jude. And he really had to step up and do things he would never have normally done. It's complete and utter commitment.'

Although Jude was penitent publicly, privately with Sienna he was justificatory. Jude told her, 'If you're not partying, you're sleeping. We can never talk when I ring. I told you I was unhappy. I told you I needed you to be there for me. Why didn't you listen to me?'

Sienna was gobsmacked and scuttled back to Mum who told the press: 'He's done a terrible thing...he's so stupid... he's a bloody idiot, and you can quote me on that. We were all really shocked when we found out. We were really hoping that Jude was the right guy for Sienna, now we just feel totally betrayed.'

In her calmer moments Sienna wondered whether he was ill like a 'sex addict' or, given that he wasn't like that with her, a 'cheataholic'. She even consulted New York celebrity agony aunt Dr Gilda Carle on what was driving Jude's infidelity. Gilda is a pure-blooded New York

princess: 'Whatever you do keep the rocks.' Sienna stopped wearing the engagement ring, but never gave it back.

Sienna was still appearing in *As You Like It* and on the first night after the revelations about Jude's infidelity, she had decided the show must go on and, minus her engagement ring, took to the stage at the Wyndham. But as she took her bow at the curtain-call, she publicly broke down in tears. Her mother told the papers: 'She is a trooper my Sienna. She has always been very strong. So much so she is still going to work at the theatre.'

But the following night her understudy had to take on the part of Celia after Sienna failed to appear. She could troop for the headlines but expecting her to parade her emotions nightly on stage was asking too much. After all in February she had said, 'I love Jude so much and I can't wait to marry him.' And for all her gilded upbringing, she was only 24.

Sienna left the £2m home she shared with Jude in north London and checked in to the Dorchester Hotel. Meanwhile, the newspapers began predicting the 'very public fall from grace' of Britain's leading man. Jude Law had gone from being branded *People* magazine's 'Sexiest Man Alive' in a special double-issue the previous November, snatching the title from Johnny Depp and being hailed as 'the most beautiful man who ever walked the earth' by *Huckabees* co-star Naomi Watts, to being 'Jude the love rat'.

Unfortunately for Jude, he had also recently played the sexually promiscuous lothario Alfie. The connection was both immediate and predictable. During his promotional

commitments for Shyer's film he had said there was a little bit of Alfie in everyone; that both men and women could relate to the character: 'We can all identify with having been either the dumped or the dumper or the cheated or the cheater at some point in our lives.'

He had said one of the most interesting things about playing the character was that he was hitting 'crunch time' – turning 30 or 31 – 'when you can't pretend you're not a man any more and, in fact, your responsibility is as a man and not a kid. Which is something I'm going through.'

Jude had often said he had grown up looking for commitment – he hadn't played the field for long before meeting and settling down with Sadie. His 'Alfie days' had been short. 'I've never been a great fan of, for want of a better description, Alfie's way of life,' he said at the film's release, 'but I think we've all been through it at some point or another.'

The similarity between his on-screen character and his recent behaviour was embarrassingly ironic. 'I rarely spend a night in my own bed,' Alfie tells his audience. In addition, in an earlier film *Music From Another Room*, Jude's character had said: 'This is passion, passion talking. I know all about it, believe me. And it feels fun. You do stupid things like this, but in the end it doesn't work. It doesn't last.'

It was all high cringe. But more importantly, it was extremely painful for Sienna. Since her parents had divorced she had remained close to both of them but had said in the past, 'I'm sure I'm psychologically blocking stuff to do with my parents' split – those feelings of

abandonment and damaged trust.' Now she was having to deal with feelings of damaged trust on an even more personal level – something she could never have imagined happening to her.

Towards the end of July the *News of the World* reported that it was 'D-Day' for Jude and Sienna, he'd been making every effort to win her back. With the help of Dr Gilda, Sienna had drawn up a anti-infidelity programme. First, Jude had to confess all his past sexual liaisons; second, he had to forswear infidelity and commit himself to faithfulness; third, he had to stop pressurising her to marry him; fourth, he had to control his temper; fifth, he had to stop seeing so much of Sadie.

Jude signed up and pledged to the programme. However, then a story broke about how three years ago he wanted to have sex with Kate Moss and Sadie set it up for him, after getting Kate on the charlie. Unfortunately, Jude had forgotten to mention Kate in his role call of the women he'd bedded.

The relationship had turned turtle in that it was now Sienna who was in charge and Jude the submissive partner. Meanwhile, she decided she would throw herself head-first into her career, all the publicity over the bust-up had made her very hot property indeed.

She was already signed up to play Francesca in Lasse Hallstrom's *Casanova*. The swashbuckling witty master of disguise whom no woman can resist has the tables turned on him by Francesca. During the shoot, she also decided that she would pay Jude back for Daisy Wright and she had a weekend romp with Daniel Craig, who was soon to be unveiled as the new James Bond.

However, the payoff was she told Jude of her infidelity to give him both a taste of his own medicine and a lesson in honesty. Given that Daniel was a buddy of his, Jude was not a happy bunny.

When promoting the film at the Venice Film Festival in September, Sienna was oozing confidence and told one journalist: 'Men are attracted to women, women are attracted to men. *Casanova* was intriguing and magnetic. I have met a few Casanovas I like and a few I have not liked – and I hope to meet a few more.' A friend commented, 'She is over her weepy phase, and over Jude. They may see each but they will never get married even though Jude doesn't know it... yet.'

At the beginning of August it was announced that Sienna was to play Edie Sedgwick – Andy Warhol's drug-addicted muse – in *Factory Girl*, a Sedgwick biopic. Sedgwick was was the model for Dylan's 'Just Like a Woman', who 'breaks just like a little girl', and also Lou Reed's 'Femme Fatale'.

Sienna had originally pulled out of the film after the shoot conflicted with her role as Celia in *As You Like It*. Tom Cruise's latest so-called girlfriend Katie Holmes stepped in to replace her but after she too pulled out Sienna took up the option. Director George Hickenlooper said he had always seen Sienna as Edie – the original 'It' girl, who died of a drugs overdose in 1971 – but whether or not it influenced Sienna's choice the film was largely to be shot in New Orleans!

When the film was being shot there in February, the producers warned her against letting Jude come over. The publicist said: 'It's a small, independent movie, so no one

can take any risks. They've already changed the schedule to make sure they could cast Sienna – they don't want anything to go wrong. She's an ambitious and hard-working girl, so she's unlikely to rebel against their wishes.'

To look the junkie part, Sienna had to diet. 'One of the problems I found when I did lose weight was that something bizarre happened to my boobs. They've always been small, but now they've disappeared – they've just shrunk.' After mastering mockney, Sienna has now learnt to speak in tabloidese: anything about boobs is guaranteed column inches in the popular press.

Jude stayed away. By now he'd realised that not only was he never going to marry Sienna but also he didn't want to. As she had become dominant in the relationship she had also become querulous and bitchy. Although she knew there was nothing sexual between him and Sadie she kicked up a mighty fuss over him spending the Christmas holidays with her and the children on a holiday in Tanzania.

Jude also went back work, which is what he does best. He went over to California in January to work on the movie *Holiday*, a romantic comedy directed by Nancy Meyers (*Something's Gotta Give*). It is about two women on vacation who find their problematic love life im-proves when they meet up and start manising. Jude gets

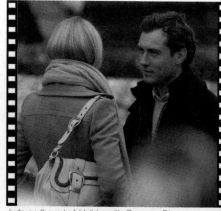

Jude on the set of *Holiday* with Cameron Diaz

Cameron Diaz. He also enraged Sienna by ignoring her Sadie edicts and had his ex-wife and children over as company.

He went back as well to working on an old Natural Nylon film that he has always wanted to make, a quirky, hallucinogenic biopic on Beatles manager Brian Epstein. After years of script-mongering, Broadway producer Vivek Tiwary finished a draft that Jude liked and which depicts Epstein's life through historical scenes, dream sequences and hallucinations. It is rumoured to be an artistically dangerous movie in the *Wilde* mode.

A mate of Jude commented in March, 'Jude's back on song. The Sienna thing is finito and he's over his nanny guilts. You are gonna see some big things from him in the future – mark my words. He's an actor, not a Punch 'n' Judy show for the media.'

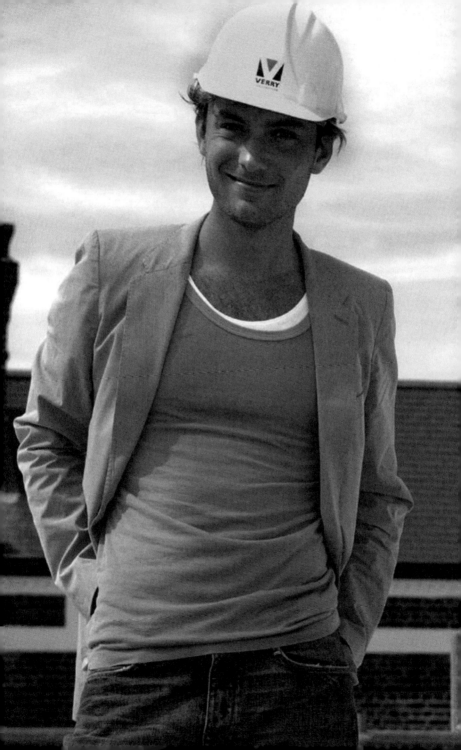

epilogue

Perfect Shadows in a Sunshine Day

Director Po-Chi Leong, who worked with Jude on
The Wisdom of Crocodiles, claimed that the best actors
always retain an air of mystery.

> *'The boring actors are the ones who
> give 100 per cent. One will never get to
> know the real Jude Law.'*

Leong is not renowned for his profundity. The only real
mystery about Jude is why anyone thinks there is a
mystery at all. Jude Law is an intelligent, charming, hand-
some man as well as being a brilliant actor, but that
doesn't save him from immaturity. Indeed, while he can
be a mesmeric actor, he rarely says anything interesting
or insightful about the parts he is playing. In this respect,
he remains an extremely good craftsman, not an artist.

The reason why people think there is a mystery to Jude
is that he is a skilled enough actor to camouflage his
immaturity. Despite his glittering public career though,
his inadequacies have despoiled his private life. Where
lies the rub?

He has done sufficient Shakespeare to know that 'all the
world's a stage, and all the men and women merely
players: they have their exits and their entrances; and
one man in his time plays many parts…' Or, perhaps
more suited to his current situation, 'Life's but a walking
shadow, a poor player that struts and frets his hour
upon the stage and then is heard no more; It is a tale
told by an idiot, full of sound and fury.' The private life
that we associate with Jude – that which is detailed in
the pages of the tabloid press – he would have us
believe is, indeed, a tale told by an idiot, signifying
nothing. But there is lot more substance to these stories

than he would have us believe.

Jude took the above Elizabethan truisms in with his dramaturgical milk, and likes to think he understands them. Yet, transparently he has failed to grasp what Shakespeare was getting at. While life is like a stage, the big difference is that the play of life lasts a lifetime not for a single production or shoot. In life, it helps to choose and find acts that we can play naturally and, perhaps more importantly, truly. This is especially so in our personal affairs. Jude has never really grasped the difference: while adept at choosing roles in his professional life that suit him as an actor, he failed dismally to do the same in his real life.

It is in the Elizabethan part he loves to play, Dr Faustus, that we find the key to unlock Jude's character. Like Faustus, Jude has sold his soul – in modern personal development-speak, his character – to sustain the part that he chooses to play in his private life. He cast himself as New Age man but while he can talk the talk, he can't walk the walk. Women find his charm, his looks and not least his fame too tempting, and he can't resist what's on offer. His 'magical powers' – his acting skills – allow him to cover up the reality of his self-deception but at the cost of never coming to terms with what it takes to be a true, intimate, faithful soulmate.

Sometimes it is better in life to be a hypocrite than believe your own act. Perhaps, Jude should have settled for the acting and played, rather than tried to be, the soulmate. But he did. And once Sadie and Sienna began to question his roving eye, then more and more of his commitment was lived in a lie. OK that hardly adds up to eternal damnation but neither is it a bed of roses.

Yet, the institution that has exposed him, the tabloid press, has in a sense been his salvation. It has in Hamlet's words 'set up a glass/ Where you may see the inmost part of you'. The unending exclusives on his private life may have been humiliating but they have been good therapy. Jude can no longer *play* commitment and faithfulness. The game is up: the rat behind the arras is slain. If he wants to womanise, he will have to do it openly; and, if he wants to be a New Age man he'll have to learn to *be* it not *play* it.

Since the bust up of his romance with Sienna, there is a renewed vigour and a greater sense of purpose to Jude. In a fact a new look of maturity. He is too sensitive and intelligent man not to know that the soap opera of his private life is trying to teach him a lesson. Some people never learn from their mistakes but Jude is not one of them. When he has realised, for example, that his acting skills need honing, he has often retreated back to the stage. Moreover, if he cleans up his private life, his acting will be the better for it, which given his vocation will probably be the driving force that will motivate him.

So 2006 might well mark the point when we will begin to 'see great things' from Jude Law the actor.

What are kings when regiment is gone,
But perfect shadows in a sunshine day?
MARLOWE